W9-AEC-602

THINKING LIKE A MOUNTAIN

Thinking Like a Mountain is printed on Enviro Antique paper
100% Post-Consumer Waste, Processed Chlorine Free

ROBERT
BATEMAN

with
Rick Archbold

THINKING
LIKE A MOUNTAIN

PENGUIN
CANADA

PENGUIN CANADA

Published by the Penguin Group

Penguin Group (Canada), 10 Alcorn Avenue, Toronto, Ontario, Canada M4V 3B2
 (a division of Pearson Penguin Canada Inc.)

Penguin Group (USA) Inc., 375 Hudson Street, New York, New York 10014, U.S.A.
Penguin Books Ltd, 80 Strand, London WC2R 0RL, England
Penguin Ireland, 25 St Stephen's Green, Dublin 2, Ireland (a division of Penguin Books Ltd)
Penguin Group (Australia), 250 Camberwell Road, Camberwell, Victoria 3124, Australia
 (a division of Pearson Australia Group Pty Ltd)
Penguin Books India Pvt Ltd, 11 Community Centre, Panchsheel Park, New Delhi — 110 017, India
Penguin Group (NZ), cnr Airborne and Rosedale Roads, Albany, Auckland 1310, New Zealand
 (a division of Pearson New Zealand Ltd)
Penguin Books (South Africa) (Pty) Ltd, 24 Sturdee Avenue, Rosebank, Johannesburg 2196, South Africa

Penguin Books Ltd, Registered Offices: 80 Strand, London WC2R 0RL, England

First published in Viking Canada hardcover by Penguin Group (Canada), a division of Pearson Penguin Canada Inc., 2000
Published in Penguin Canada paperback by Penguin Group (Canada), a division of Pearson Penguin Canada Inc., 2002

10 9 8 7 6 5 4 3

Copyright © Robert Bateman, 2000

The following trademarks and service mark appear in this book: Land Rover™; Hypercar^SM, developed by the Hypercar Center®, is a service mark of the Rocky Mountain Institute.

Design by Counterpunch / Linda Gustafson
Manufactured in Canada.

NATIONAL LIBRARY OF CANADA CATALOGUING IN PUBLICATION

Bateman, Robert, 1930–
 Thinking like a mountain

Includes bibliographical references.
ISBN 0-14-301272-X

1. Nature conservation. 2. Nature—Effect of human beings on. I. Title.

QH75.B37 2002 333.7'2 C2002-900178-1

Visit Penguin Books' website at **www.penguin.ca**

To my grandchildren and
my grandchildren's grandchildren

Contents

Preface

In May 2000, I celebrated my seventieth birthday. Somehow this one was different from other turnings of the decade. I marked thirty, forty, fifty – even sixty – with little more than a jaunty wave at the past and an interested glance at the future. But this time, even though I still feel much as I did at thirty, the road ahead looks suddenly shorter – so I try to savour each moment while I'm in it. All the same, my mind keeps ambling back over the 70 percent of the twentieth century through which I've lived.

My mother would have turned one hundred this year. Together, her life and mine have spanned ten decades. She grew up in Springhill, Nova Scotia, in a world heated by wood and coal and lit by oil lamps, where people generally travelled by foot, by horse or by boat. Trains were the only mode of transportation that did not stretch back into prehistory. My mother and I witnessed incredible changes during "our century." She was born into a world without electricity but

lived to watch a man walk on the moon. When I was a boy, the idea of a computer was science fiction fantasy but this book was delivered to the publisher electronically.

Much of the technology that has so radically transformed human life over the past hundred years has saved lives, cured illnesses or improved communication. But the speed and volume of these new discoveries has imprinted on us the idea that endlessly accelerating growth and technological change are good in themselves. We've indentured ourselves to the master called "Progress" and neglected to look after the planet on which all depends.

Marshall McLuhan once said that when you hear someone using the word Progress, you know you are dealing with a nineteenth-century brain. Too many nineteenth-century brains have left us with too many twenty-first-century problems. As the great biologist and ecologist E.O. Wilson has said, the past century will be remembered less for its technological prowess than for its destruction of diversity. Humanity needs a new definition of Progress, one that is more elegant and sophisticated, one that values our heritage, both natural and human. We need to think carefully about the health and well-being of future generations.

At my seventieth birthday party, I was happily surrounded by friends and relatives, including my children and my four grandchildren. There were performances and a lot of laughter. My wife Birgit and I and my brothers Jack and Ross looked back on our lives and recalled the worlds we have known and shared. Our grandchildren, the eldest of whom is four, loved the party too, but in their minds, it will soon become a blur.

Other memories will be made and lost in their lifetimes. All going well, they will learn many marvels of earth, air, and stream. They will see the miracle of renewal – how the world and its creatures replenish themselves according to the normal cycles and processes of nature. But numerous memories will never be made – because the last couple of generations will have destroyed so much. What will our world be like when my grandchildren celebrate their seventieth birthdays? When I ask myself this question, I do not feel so happy.

That is why I have written this book. That is why, since the 1960s, I have been among the legions of people paying attention to the way we have been mistreating the planet. I have given countless talks on the topic of our disappearing worlds to a wide variety of groups, ranging from the Society

of Environmental Toxicology and Chemistry (SETAC) to the annual meeting of the Certified General Accountants of Canada. In my thinking and in my talks, I have constantly struggled to get to the heart of the problems plaguing our planet, peeling back the onion-like layers of thought, habit and error that have led us to destroy our human and natural inheritance.

This book springs from some of those talks, from personal experience and from observations and conversations about the state of the natural world. In the pages that follow I have described some of the destruction but I have also explored some good, new ideas and introduced good people, both prominent and obscure, who are acting now to renew the Earth. This volume is not a scholarly analysis, although it has been influenced by the work and writing of many thinkers. It is a voyage of remembering and of discovery. I offer it as food for thought, as reason for hope. For it is only in thoughtful reflection and in hopeful action that we will be able to pass on to our children's children a world worth keeping.

Robert Bateman
Salt Spring Island, British Columbia
June 2000

The cowman who cleans his range of wolves does not realize that he is taking over the wolf's job of trimming the herd to fit the range. He has not learned to think like a mountain. Hence we have dustbowls, and rivers washing the future into the sea.

Aldo Leopold

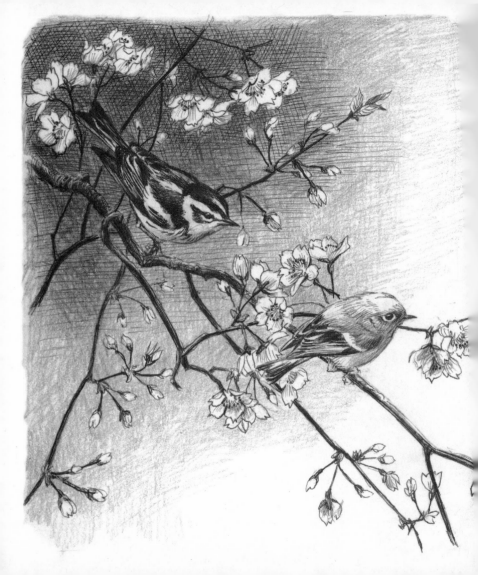

PART ONE

Getting to Know the Neighbours

*Nature! We are surrounded and embraced by her:
powerless to separate ourselves from her, and powerless to
penetrate beyond her. Without asking, or warning, she
snatches us up into her circling dance, and whirls us on
until we are tired, and drops us from her arms.*

Goethe

*Of all the questions which can come before this
nation, ... there is none which compares in importance
with the great central task of leaving this land even a
better land for our descendants than it is for us*

Theodore Roosevelt

A Day in May

Over the years, I've often spoken about one of the most memorable experiences of my childhood, a golden day in May, when I was perhaps ten or eleven. That morning – it must have been a Saturday – I ventured down the steep path into the ravine behind our house, one of many ancient river valleys that provide a tracery of wildness through Toronto's urban landscape. That ravine held the first forest I got to know; from the time I could walk, I explored it and made it my personal domain. As I grew more interested in wildlife, I began to learn about its inhabitants: the resident birds, raccoons and squirrels. To my fledgling eyes, my ravine seemed impossibly rich and varied.

Because the valley was wet, giant willows flourished there, as did a jungly tangle of fox grapes and Virginia creeper. Each spring, the stream that ran along the foot of the ravine overflowed, leaving pools where tadpoles grew into frogs and painted turtles sometimes swam. In early May, before the

canopy leafed in, the forest floor turned into a brilliant carpet of wildflowers: trilliums, hepaticas and trout lilies.

I didn't know it then, but my private woodland was only a poor remnant of the rich and majestic mixed forests of maple, beech, ash, white pine and hemlock that had covered most of southern Ontario before the Europeans came. And even back in the early 1940s, the plants and animals shared their space with the inevitable ambassadors of Progress. Twice a day, a steam engine belonging to the city's now long-gone Belt Line railway puffed its way along a track to deliver coal and ice to the residents of North Toronto. But this predictable daily intrusion did not discourage the annual spring visitation of migrating birds.

In my memory, the day dawns sunny, with the promise of unseasonable warmth. As quietly as one of the characters from Ernest Thompson Seton's *Two Little Savages* – I devoured Seton's books from a young age – I creep down to my favourite spot, a bower of wild plum blossoms that gives me excellent views of the branches below, already brushed with spring's first greenery. There I wait, breathing the rich smells of damp earth and decaying leaves, mixed with plum blossom perfume, and listening to the chirp and chatter of the local

birds — totally at ease in my familiar territory. Time passes without any sense of urgency. The sun rises and the day grows warmer. Then, suddenly, as if at some prearranged signal, the migrants come.

Within the space of less than an hour on that unforgettable morning, I saw legions of migrating warblers, as well as kinglets, a yellow-bellied sapsucker and a ruby-throated hummingbird. It seemed as if every branch of every tree was dripping with birds. If perfect happiness is possible, then this was the day I experienced it.

The North Toronto house built for my parents still stands, and the ravine behind it continues to provide a pathway for migratory birds each spring — though their numbers are fewer and the species less varied. The verdant creek has been imprisoned in a storm sewer, and no kids go tadpoling in the spring because the tadpoles have vanished.

But there have also been positive developments. The train no longer spills dirty smoke into the clear spring air from its coal-fired boilers. Its tracks were pulled up long ago, and the old rail bed has gone back to nature. The forest itself is thick and jungly, still a good place to get lost in.

After the tracks were dismantled, some residents proposed that the lot lines of the properties on either side of the ravine be extended, adding a few feet to each yard. Fortunately, a citizens' group insisted that the ravine remain open to both people and wildlife. These must have been citizens who cared about the generations to come.

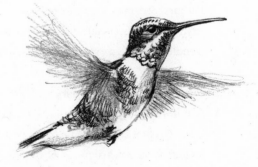

Portrait of the Artist as a Young Birdwatcher

Even before I reached my teens, I knew for certain that two passions would rule my life: wildlife and art. My two best childhood friends, Alan Gordon and Don Smith, who both grew up to be professional biologists, shared my love of nature. Our boyhood excursions together were always voyages of exploration and discovery.

In those days, the early 1940s, the unspoiled countryside was only a short distance away from our North Toronto neighbourhood. If we hiked a quarter-mile to the west of nearby Bathurst Street, now an urban thoroughfare in the heart of the city, we entered a magical realm of open fields, marshes and woodlots. There we saw our first meadowlarks and bobolinks, our first owls. If we hopped on our bikes, we could venture even farther, exploring an incredible variety of habitats, from lakeshore cliffs to deep forest glades, all within range of a short ride. We climbed trees to peer into nests; we lay patiently beside the burrows of meadow voles to observe their passing.

We would track a bird call to its source, hoping for a glimpse of something rare or wonderful. Unlike so many kids today, we were never bored.

Our primary passion was birdwatching, which combined our love of nature with the widespread human propensity for collecting. The beauty of birdwatching, a pastime I still enjoy, is that you don't need to physically gather anything. You simply keep a list. Alan and Don and I were inveterate bird listers almost from the day we met. During one two-year period when I was in my teens, I managed to record over one hundred different bird species – including some migrating white pelicans I spotted flying overhead one morning as I delivered newspapers – all observed in my immediate neighbourhood.

Our passion took on a considerably more scientific bent after my mother sent Alan and me to join the Junior Field Naturalists Club at the Royal Ontario Museum. We were both about twelve and already veteran field naturalists of a sort, who'd made detailed notes about our most interesting discoveries and kept careful lists of what we'd seen. Now we began to acquire a more systematic way of looking at nature and an idea of how each individual related to the whole. But we didn't lose our passion or our sense of wonder.

It is this amazement at the complexity of nature that has fed my life and my art. It is this joy that I want to pass on to our children, so that they, too, will become lifelong observers, who appreciate their natural inheritance.

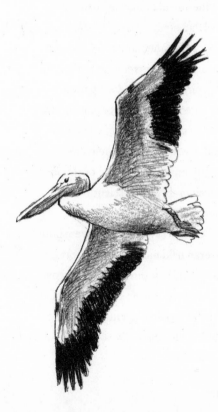

My People

My mother's people came from Nova Scotia by way of the
Thirteen Colonies. They were United Empire Loyalists who
moved north because of the American Revolution. My mater-
nal grandfather, Clement DeBryus McLellan, became a ship's
carpenter during the brief golden age of Nova Scotia ship-
building in the mid-nineteenth century, when Nova Scotia
timber was made into some of the finest ships that ever sailed.
My grandfather and my great-grandfather plied their trade at
Spencer's Island along the Parrsboro shore of the province's
northern peninsula, crafting clipper ships, schooners, barques
and brigantines in one of the greatest commercial shipbuilding
centres in the world.

Then along came the age of steam. Sailing ships soon
became obsolete, and my great-grandfather had to turn his
carpentering to other uses. So he started a woodworking
factory in nearby Springhill, a coal-mining centre that was
part of the new industrial age. But my mother's people did

not all abandon the sea. Some of them became fishermen.

I knew only one of these relatives personally – my mother's first cousin Ebenezer Dickie, the last of a line of Nova Scotia fishermen. In 1946, when I was sixteen, I spent the summer visiting my maritime relatives and got a taste of my cousin's trade.

Early one morning, Ebenezer took me with him as he went fishing for shad, a type of herring. Eb had been fishing since he was a boy, having learned the skills from his father. He owned a small boat with an inboard motor and a set of heavy oars to be used when the motor failed. Ordinarily, Eb fished alone, so he welcomed my help.

My most vivid image from that sun-sparkled day is of his hands – a fisherman's hands, all calloused and cut, where the net filaments had sliced through them. But as we pulled in the net teeming with slippery shad, he seemed oblivious to his wounds. Although his life was hard and the job conditions often harsh, he was in charge of his own life, and his work was meaningful.

When the great American microbiologist René Dubos was asked to name the most important problem humanity would face in the future, he answered, "the disappearance

of meaningful work." In 1973, E.F. Schumacher, the British ecologist and economist, wrote something similar in his land-mark book, *Small Is Beautiful*: "Next to the family," he said, "it is work and the relationships established by work that are the true foundations of society. If the foundations are unsound, how [can] society be sound?"

Like my cousin Ebenezer, my father knew the meaning of work. He had been born in the farm country of eastern Ontario, on a hundred acres his forebears had cleared and planted after arriv-ing from Ireland – part of that country's nineteenth-century wave of emigration. Although the original Bateman farm is no longer in the family, it is still being worked, and the place next door is owned and operated by Bateman cousins.

The last time I visited, I noticed again the fieldstone stable wall and the great, weathered, silvery barn boards of white pine. I also shake my head in admiration when I look at the barn's old beams. You can still see the axe marks on them, where a craftsman squared the great white pines with swift and accurate strokes, transforming mighty tree trunks into massive but structurally beautiful girders.

Dad grew up doing farm chores – sowing and harvesting

grain and milking cows – living by the dictates of the weather and the season. The work was back breaking and could be heart breaking, but it was unendingly varied and kept him in the embrace of nature. Even though he grew up to become an electrical engineer, he remembered the land and a world free of electricity and chemical fertilizers. Like most members of his generation, he welcomed these perceived boons to humanity, but he didn't place too much faith in them. Were he alive today, he would agree that we must not become slaves to our conveniences.

Cell phones, computers and Internet access have allowed twenty-first-century North Americans to work faster than anyone in recorded history. Much of our effort, however, keeps us from the beauty and vigour of the natural world and from our own histories. If we looked back to the past – not in nostalgia, but with the purpose of retrieving the good things we've lost – our work and our lives would become more meaningful.

The Call of a Wolf

I've always been drawn to the North. As a boy, I read stories
like *The Call of the Wild* by Jack London and *The Feet of the
Furtive* by Sir Charles G.D. Roberts. Canada's great boreal
landscapes loomed wild in my imagination and beckoned me to
explore their rugged treasures. When my family bought a cot-
tage in Haliburton, I reached the borderline between South and
North, a place where pioneer farms rubbed shoulders with
rockbound lakes and forests of pine and spruce. But I got my
first taste of the North during the summer of my seventeenth
year, the first I spent working at a wildlife research camp in
Algonquin Park.

I'm sure my pay and job description would appall many:
I filled in potholes, dug garbage pits and dried dishes that had
been "washed" by the camp cook. (His method was to pour
boiling water over the dirty plates and cutlery, which meant I
had to clean the egg off the forks with the tea towel.) Because
I was a serious young naturalist by then, I was given some

"posh" jobs, too: I ran the bird count plots; operated the small mammal traplines, skinning and stuffing the mice to make a reference collection; and helped out with road kill autopsies.

Nature has its Romantic side, but I saw a lot of its uglier parts that summer. As we examined animals who had met their deaths on the highways, we discovered that the graceful, vegetarian deer were full of parasites, which had plagued their existence when they were alive. The bears, however, whose diet was less pure, were surprisingly free of parasitic pests. All the same, we'd find other things, like dish cloths and one Player's cigarette package, inside the garbage-eating bruins.

That first summer in Algonquin I cemented my sense of the kind of life I wanted to lead and the type of people I wanted to spend my time with. A middle-class kid from North Toronto, I had never before encountered the fascinating species known as the biological field worker, but my summers at Algonquin gave me ample opportunity to learn their ways. My newly discovered companions were as at home in the bush as in the laboratory, cultured and yet completely down to earth. They knew how to dubbin a boot and sharpen an axe. But after supper, the discussion often moved from the day's discoveries to talk of James Thurber or Immanuel Kant or Sir Arthur Conan

Doyle's novel *The White Company*, set in mediaeval England, which became the basis for a group game we sometimes played. These men's musical tastes ranged from Beethoven to Gilbert and Sullivan to traditional folk songs.

For the most part, I enjoyed the work, but I lived for my spare time. Almost every evening after supper, I would take one of the camp canoes and paddle to a secluded spot so I could paint. By then, I was steeped in the legacy of Tom Thomson and the Group of Seven, and I took pride in paddling like Tom, kneeling just aft of centre and off to one side – Ojibway style. In this position, the angle where the floor of the canoe meets the wall forms a longer, sharper line in the water, and this helps you keep the canoe on course. And since you are close to the gunwale, you don't have to reach far to the side. So it's easier not to bump the paddle, and you can take little strokes by moving your upper hand out over the side on the downstroke and back across your lap on the upstroke, while pivoting on your lower hand. The paddle should sail like a bird's wing just above the surface, and the only sound should be that of droplets falling off the blade. If I wanted to be really quiet, I could keep my blade in the water for the whole stroke. This was the method I chose for observing wildlife.

One evening, after the chores were done, I took my canoe out to Lake Sasajewun and was lured north, past the narrows, to an island nestled among lily pads in a dead-end inlet. The island was a glacial erratic, a rock left behind many lifetimes before by retreating ice. During my last visit, I had been entertained by five snorting, indignant otters, but that evening, I was alone and far from shore. I was even relatively free of the mosquitoes and black flies that swarmed me and bungled into the gooey oils on the fresh paintings. (A half-century later, some of their mummified bodies are still part of those early works!)

Twilight descended before I finished. In those days, I worked only in the field and never retouched my paintings later, so as not to spoil the spirit of the moment. I'd found my scene that evening by looking north, toward the far end of the lake, beyond which lay a "wilderness area," out of bounds to the public. A hermit thrush was singing, its song spiralling upward, beyond hearing range, like the music from some reedy yet celestial pipe organ.

I always painted until dusk, stretching my time to the limit, but on this occasion, for some reason, I worked long past sunset, lingering in the darkness, waiting for ... something. The moon began to rise, burnishing the edges of the black spruce

spires with glowing silver, then emerging above the treetops in gleaming fullness.

And then I heard it.

Starting as a low moan and moving up the scale to a full-throated contralto, a wolf's howl penetrated the darkness. Time stopped. I floated in a pool of blackness, alone with the moon and the soul-filling sound. My first wolf. The hair stands up on the back of my neck even now, as I relive the moment.

I returned to Algonquin for each of the three succeeding summers, the last as a university student at the park's fisheries research station. By that last season, however, I knew that the Algonquin Park I had come to know had been devastated by logging. Even here, commercial harvesting had irreversibly depleted the hemlock-clad ridges, destroying not only the natural beauty of the area, but also an important genetic pool. Scientists are just beginning to understand genetic particularity within a species, how trees have evolved to form their own intricate individuality, adjusted to their site. But once a stand of hemlock is cut down, its tiny gene pool is gone forever. Even though Algonquin hemlock has little commercial value, industrial logging takes it as raw material for cheap

wood fibre that may or may not be marketable.

The story of the Algonquin wolves is also tragic. Even where they are protected, poaching is common because enforcement is inadequate. This is especially sad because recent genetic research tells us that Algonquin Park wolves may be closely related to the endangered red wolf, which some scientists believe is the original North American wolf. The Algonquin animals may even be a unique species.

The call of the wolf will last only as long as we protect this ancient creature and its habitat. Extinction is forever.

Roving around the World

About mid-morning the Ba Mbuti began arriving. They had
agreed to take us on a net hunt and we had promised to provide
the transportation – the Land Rover that had been our home
away from home since leaving Toronto many months before
on an adventure that would eventually take us around the
world. The Land Rover was roomy enough for me and my two
travelling companions, Bristol Foster and Erik Thorn, both
friends I'd known since our days as members of the field natu-
ralists club at the Royal Ontario Museum. But here, in the
equatorial rainforest of what in 1957 was still called the Belgian
Congo, the carrying capacity of our vehicle was about to be put
to the test.

As more and more of the pygmy hunters arrived with their
nets, we made room for them until the Land Rover seemed
full enough. Then the women began to arrive, some carrying
infants. (Since the women did not hunt, we were puzzled by
their presence, but we were told they were essential.) When

Bristol peered under the vehicle to see if the springs would take the weight, he reported that the springs were flattened and resting on the axles.

The lead hunter, Vaizi, signalled us to start, and with three of us shoving, we managed to close the back doors. Two more hunters arrived and had to be passed over the heads of the others, into the mass of humanity. When we counted everyone, we couldn't believe how many people had jammed themselves in: twenty-two, not including babies! Vaizi and three others climbed onto the front hood and sat on the spare tire, nicely blocking Bristol's vision.

As we gained speed over the rough, winding road, the people began to sing. Our host at nearby Camp Putnam had warned us to expect this. (At the camp, we'd also met Oxford anthropologist Colin Turnbull, who subsequently became a leading authority on the Ba Mbuti, and Newton Beal, a musicologist from Ohio University, who was planning to spend the next year studying the Ba Mbuti's unique music.) Listening to their song, I realized how complex it was – and wrote this description of it in my diary:

"October 29, 1957... Their singing is totally unlike Bantu singing, or, for that matter, almost any other singing in the

world. The pygmies are natural harmonizers and improvise chords.... The songs often take the form of rounds; sometimes successive notes are sung by different individuals scattered amongst the group, causing the tune to bounce around. Each person may have his own little tune, which he sings at the appropriate beat.... Some yodelling may be added. The overall effect... has been compared to chimes or a glockenspiel. The words may describe the forest and its animals or tell a story, but most of their songs are joyful songs of thanksgiving."

It could be argued that the Ba Mbuti and many other hunter-gatherers form almost perfect societies. They have a positive attitude toward nature and toward each other, which explains the theme of their music. Although their lives are not easy, they have plenty of time for fun and play. When they decide to make camp, they can build all their dwellings in less than half a day. When they start to have difficulty hunting forest animals and gathering honey and forest plants, they move on. Soon their abandoned huts decompose, becoming part of the forest litter, and nature rebuilds itself.

Once we arrived at the appointed hunting place, deep in the

forest, the women and children disappeared. We three giant Canadians staggered behind, each following his assigned hunter along an invisible trail, our size and awkwardness making it difficult to keep up with our hosts. Finally, the hunters took the nets – about three feet high and a hundred feet long, with a two-inch mesh made from the stems of plants growing nearby – and strung them together in a giant arc. We crouched in silence. Suddenly, a rowdy clamour broke out in the forest ahead of us. The women and children were approaching with yells and cries and yodels, each call giving information to a particular hunter and collectively designed to drive game into the net.

That morning, the hunting was poor: the Ba Mbuti reaped only one duiker, a small antelope, but this they butchered carefully according to complex relationships and customs. It was a well-endowed male, and two young women, presumably unmarried, jumped with glee when they were handed the ample gonads.

Erik Thorn left us at the end of the African phase of our trip, but Bristol and I continued on a trek around the world that took us to India, Burma, Thailand, Malaya and finally Aus-

tralia. We arrived back in Toronto fourteen months after our departure. During our travels, we collected a trove of objects that were precious to us, and some of them became instructional tools when I returned to my life as a teacher of geography and art. As an art teacher in the late 1950s and early 1960s, I was often called upon to give talks about my travels. But the more I spoke about those experiences, the more I realized that much of what I was describing was already gone forever – and most of the rest was going fast. I soon began calling my lectures "The Disappearing World," and told my audiences that the last half of the twentieth century would see the disappearance of more human and natural heritage than any other time in the history of humanity.

Some have claimed that the burning of the library at Alexandria in the first century BC represented the greatest loss of information ever suffered by humanity. Every month, however, huge volumes of knowledge about the natural world vanish forever as we dismiss and destroy societies like that of the Ba Mbuti, whose wise men and women know many valuable secrets, including the healing properties of plants. Vegetation like the tropical rosy periwinkle (which provides drugs used in the treatment of Hodgkins' disease and childhood leukemia)

may liberate many from pain and suffering. The greed of others, however, may destroy these natural gifts forever.

I often ask my audiences what is replacing these things. Then I sum up the possible answers to the question with one metaphor: "instant pudding" – that slick, sweet goop that comes in assorted flavours, all artificial. Instant pudding is quick and easy to prepare, but you won't have heard of half the ingredients. You didn't put them there, and you wouldn't know what they'd do to you even if you could understand the label.

My listeners immediately get the analogy. The modern world is turning people into package purchasers with no control over things that can deeply affect their lives and health. We are losing touch with the world of nature and with ourselves as humans.

In my sketchbook from that trip around the world, I made little drawings and watercolours every time I saw something new or different: clothing, shelters, dogs, landscapes – and, of course, wildlife. Perhaps that's when I first began to realize that variety really *is* the spice of life. Tragically, we are wiping out variety and replacing it with uniformity. We roam around the world's websites with our search engines while the real world slips away.

Getting to Know the Neighbours

Every autumn, in the days when I was still teaching art and geography at Nelson High School in Burlington, Ontario, I would take my art class out for an afternoon at Mount Nemo, one of the high points on the Niagara Escarpment, where it passes through Halton County. Those were the best classes I taught during my twenty years as a teacher.

Before each field trip, I talked to my students about Japanese art and philosophy, about haiku poetry, raku pottery and Zen meditation, and I often read a passage from one of my favourite short stories, Ernest Hemingway's "Big Two-Hearted River," in which Nick comes home from war and remembers how he used to go to a very special river with his dad to catch trout. His memory is of an intense experience, of living in the here and now. I hoped my students would feel the same joy on Mount Nemo and carry some of it with them for the rest of their lives.

On those afternoons, my students' task was to immerse

themselves in three separate and distinct natural environments, having no contact with their classmates or with any other human being. They were to observe each environment as intimately as possible. The first environment was a meadow, the second was a cave and the third was a forest – three places as different as a Shinto temple garden in Kyoto, Chartres Cathedral near Paris and the Guggenheim Museum in New York.

They spent an unbroken hour in each place, writing and drawing in pen and ink on a long, narrow piece of paper designed to resemble a Japanese scroll. For the first hour, they did nothing but describe the meadow in stream-of-consciousness style, using words, pictures and empty space, recording what they were seeing, hearing, smelling, feeling. I asked them to be absolutely literal observers of the tiny world they were inhabiting for that hour. Then they repeated the exercise in the cave and in the woodland.

This exercise encapsulates my philosophy of education, which is based on the word *respect*: respect between student and teacher; respect for our cultural heritage; and respect for our natural neighbours.

We've lost our respect for other species partly because we don't even know their names. Names matter. Any teacher

knows how students value being recognized by name. Hunter-gatherer peoples in the tropical world can identify thousands of species of plants and animals, but the average North American can manage only about ten. Yet the average North American can recognize about a thousand corporate logos.

We need to reverse this situation and reverse it fast – and the best way to do this is through education. It would be easy to supply classrooms with copies of field guides (like the classic Peterson's) – and in my experience, students love quizzes about local flora and fauna. If we give our children tools like these, they will get to know their plant and animal neighbours and grow to love the world of natural wonders.

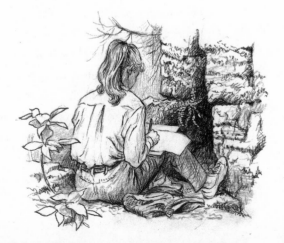

Natural Art

My career as an artist really began in 1967. It was Canada's Centennial year, a bright and heady time that prompted many unique events and celebrations. My personal Centennial project was to record in paint the place where I lived and taught – Halton County, Ontario – as it had been at the time of Confederation in 1867 and still was a hundred years later. My work featured evidence of both human and natural heritage: the forests, farms and hamlets of this rich agricultural area. Alas, even as I was painting these places, they were under sentence of death. Barns, railway stations, rail fences, heritage homes and even a church fell to the bulldozers over the next ten years. They had lasted a century or more but were destroyed within a decade by urban sprawl.

My paintings of those precious landscapes were some of the first I ever sold, and they marked the beginning of my "career as an artist." As the years passed and I discovered how the art establishment looks down on "wildlife art," I began to

wonder how wild spaces and animals had been viewed at other times in history. As I delved into the topic, I discovered that cultures in most times and places celebrated wildness in their art.

But there was one exception: the Western world, dating from the time that the church began to dominate the production of art, during the Middle Ages. To Europeans emerging from the Dark Ages, nature was an enemy to be overcome, so mediaeval artists depicted it that way. Although the great Gothic churches represent some of humanity's most sublime works of art and though their leafy designs and pillars are said to resemble northern forests, they generally depict nature in mythical forms – as weird griffins and strange gargoyles. And from the Renaissance to the early twentieth century, the typical position for painted wild animals was at the point of a spear. They were acceptable as long as they were shown as cowering quarry or hanging by their feet beside a bunch of grapes, ready for the table. Domestic animals, on the other hand, were often painted with affection. I can think of only a few exceptions: Dürer's hare, Rembrandt's elephant (a tame elephant, mind you) and Picasso's bicycle-seat baboon.

Only in the modern era have serious artists tackled wildlife

as a subject deserving of respect. Since I know my own work best, I'll use a personal example, but there are thousands among the works of others. In my painting *Clear Night — Wolves*, I have shown a wolf pack in the forest gloom looking out at me – or you – from behind a scraggly little tree. They are on an opposite hill at eye level, viewing me with care and respect. These feelings are mutual, for this is how I approach all of nature. I respect a slug as much as I do a sleek cougar, a gentle fawn or even a senator. Some plants and animals seem noble or beautiful to us, others do not. But they all deserve our respect. Could it be that our centuries-old prejudice against nature in art is a reflection of our society's attitude toward the natural world as something to be feared, conquered and used only for our own benefit?

I once saw a poster in the Munich Art Museum that read "*Kunst öffnet die Augen*" (Art opens our eyes). I believe this to be true of all subject matter and styles, including abstract art, but the natural world as seen by artists is also a suitable subject. It has a crucial role to play, not only in bringing pleasure and appreciation to individual lives but in showing us all the natural treasures we need to cherish and protect.

Aristocrats of Time and Space

Children are naturally enchanted by the world of trees, birds, plants and rivers, and some take delight in drawing and painting them. Most stay interested until the age of twelve or thirteen, but some, like me, never lose their enthusiasm. My own career as an artist and naturalist began when I was very young, and I got serious about both these pursuits when I was in grade seven. Luckily, my parents encouraged me, and I grew up in a place where I could explore both art and nature to the fullest. Although I was born in 1930 and some of my earliest memories are of Depression-era Toronto, the times also worked in my favour. My family was never wealthy, but my father always had a job. We had enough food on the table and a nice house to live in. In hindsight, I can see that anyone born around the same time was a member of a lucky generation.

I sometimes say that we were the aristocrats of time, space, history and geography. We were too young to go to war, and we came of age at the beginning of the baby boom. As a

Depression child, I was a scarce commodity in the early 1950s after I graduated from university, so I could pretty well choose any job I wanted. Everywhere I turned, ten doors opened for me. I've spent my adult life in the most prosperous and privileged place on Earth.

But my children and grandchildren are very lucky, too. All of us alive right now in the West, the "developed world," are aristocrats by any historical or geographical standard. We have more wealth, more power, more technology and more information than any people who have ever lived on this planet. Sometimes aristocrats are called *nobles*, which reminds us that as people of privilege, we are meant to act nobly – toward our fellows and toward the planet.

A wise woman once asked me poignantly: "Doesn't anyone have grandchildren anymore?" To act nobly is most certainly to make good decisions for our grandchildren's futures, yet many of us seem to have forgotten how to think this way. There is a traditional North American Native saying that could help us all: "We must plan our path not just for this generation and the next but for seven generations to come." Does this sound impossible in a time when stock market traders plan for the next few seconds, corporate CEOs manage primarily for

short-term profit and politicians can't seem to see beyond the next election?

But the questions on the other side are stronger: Can we possibly continue to live as we do, spending the Earth's resources as if there was no tomorrow? Will our species survive the continuing onslaught of its own overconsumption? I see signs of hope, as well as portents of disaster. The human race may finally be starting to learn from its mistakes. We may be standing on the brink of a revolution in the way we relate to all the other creatures and living systems on the planet. But before we can find a new path, we need to take our heads out of the sand and embrace new ways of life. We need to pay attention.

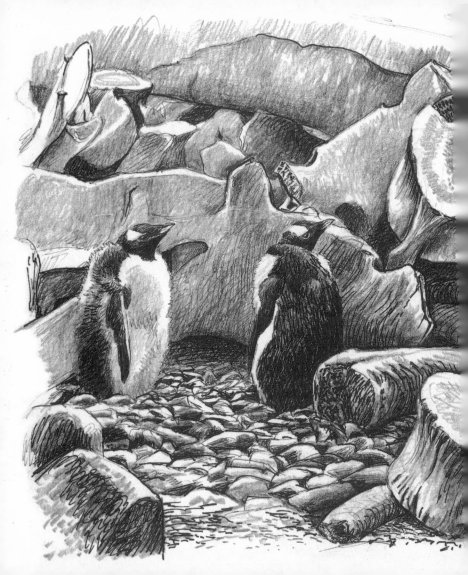

PART TWO

Message in the Bones

*We can change the way we think and behave in decades,
which is just as well, because if we don't change fast,
we will be very sorry we ever invented civilization.*

Gwyn Dyer

*Let's treat this planet as if we plan to stay here and not
as if it is a disposable item. Mars is not ready yet and
never will be.*

Monte Hummel

Message in the Bones

I did not know whether to laugh or to cry. So I sat down on the edge of one of the great whalebones, took out my sketchbook, and tried to capture the scene. I felt like laughing in sheer delight because of the bones' great forms – like an exhibition of Henry Moore sculptures I hadn't known about. But I felt like crying inside because of what they represented – the wholesale slaughter of so many majestic sea creatures – and I was also saddened by the gentoo penguin chicks huddled nearby.

Our group from the ship *Lindblad Explorer* was visiting Port Lockroy on the Antarctic Peninsula. It was the austral autumn, and the first snowflakes of winter had fallen the day before – which meant the penguin chicks were in trouble. They had to lose their down and get out to sea before freeze-up or they would die of starvation. Patiently standing in their mucky pebble nests, they were hoping for a parent to feed them. But soon, the adults would have to launch out into the open sea, and then there would be no more feeding visits.

Nature can be cruel, but the cruelty of humanity seems to know no bounds. There I was, sitting in the graveyard of scores of great whales, relics from the age of massive commercial whaling. After the waters of New England, Europe and the rest of the northern hemisphere had been depleted, the ships moved south to hunt down the intelligent giants of the Antarctic. But that was only part of the story. The whalers did not even leave a healthy breeding stock, though it would have been to their commercial advantage to do so. They scraped the bottom of the barrel, and we still seem to be treating the natural world that way.

The oceans are the great unseen tragedy in the modern history of the Earth. In one of my recent paintings, I show a Pacific white-sided dolphin and a Laysan albatross as lifeless forms in a drift net. These are euphemistically known as "by-catch" in the trade, but scientist Sylvia Earle has more aptly called the phenomenon "murder of wildlife in the sea." Every year, industrial fishing kills an estimated one million mammals — seals, whales, dolphins, sea turtles and many others. They are the garbage of the fishing industry. A million birds meet the same fate, as do countless millions of fish, including many

endangered species. Fishing boats annually catch and throw
overboard 27 million tonnes of dead or dying marine life.

The fishing vessels waging this war are high-tech
dreadnoughts – huge, fast, powerful and bristling with
electronic equipment, built to search and destroy. But none

of the technology comes cheaply. The cost of the vessels is
measured in millions of dollars, and the borrowing and
government grants required to keep them running are meas-
ured in the billions. If the industrial fishing machine is not fed,
the investment is lost, so hard-earned money is paid in taxes
to subsidize the insanity.

Trawlers and long liners are two of the worst of these
scourges of the marine world. Trawlers, the mega-bulldozers
of the sea, drag giant, weighted nets along the ocean floor,
destroying everything in their path. It is as if corn were being
harvested by a machine that scraped away the first two inches
of topsoil. According to scientists, this process is devastating up
to 150 times more habitat than all the forest clearcutting in the
world. This practice, in addition to overharvesting, explains
why the northern cod stocks off the coast of Newfoundland
have plummeted. Trawlers should be banned in favour of
stationary gear – traps, hooks and lines, or regular-sized nets.

Long liners lay out up to eighty miles of lines, with thousands of hooks, baited with squid. Because albatross find squid irresistible, it is estimated that thousands of these majestic birds are killed annually by the long liners, bringing some populations to the brink of extinction. And when the vessels haul in fish that are considered unsaleable or too small, these "extras" are killed and dumped.

The senseless destruction does not need to continue. If the squid were dyed blue, they would be invisible to the albatross and therefore not a deadly temptation. The cost of this simple procedure would be more than offset by the money saved, since the hooks and lines would no longer be tangled by the big birds.

Because I like to eat shrimp, I have also been troubled to learn that the by-catch ratio for the shellfish is up to one in fourteen — that is, one kilo of shrimp caught industrially can result in fourteen kilos of by-catch — marine life killed and thrown away. And none of this waste is necessary. An independent shrimp fisherman from Nova Scotia visited our studio a couple of years ago. When I asked him about his by-catch ratio, he said he had none because he used a stainless steel mesh that screened away noncommercial shrimp and fish from the

mouth of the trap. The only problem was that it cost him five thousand dollars a month to refurbish the meshes, so he had to charge more for his shrimp. Is the price worth it? Ask yourself if you would be prepared to pay a bit more for much of what you buy in order to protect nature and our human future.

There was a time when the best things in life seemed to be free: clean water, clean air, the song of a bird and a balanced ecosystem. But we have already done so much harm to the natural environment that we now have to start paying to clean things up. If we want breatheable air, we will have to develop alternate energy sources and vehicles that use less fossil fuel. If we want to save our ecosystems, we will have to purchase more habitats and effectively enforce the laws that conserve them. If we want to protect the creatures of the ocean, we will have to invest in procedures that eliminate by-catch and the wholesale destruction of sea life. In the long run, a good number of these new methods will actually bring expenses down.

You have to spend money to make money, and the same can be said of protecting our environmental investment. Success stories like the Thames River in England and Lake Erie – cleaned up after many years of pollution – did not come about

without financial sacrifice. But the expense was worth it. In the past, nature did give us something close to a "free lunch," but now we're using our natural resources so quickly that supplies are running out. As we get closer to the zero mark, everyone, from key decision makers to a shopper buying a tin of salmon, will need to remember that the benefits of ocean, land and air come at a cost.

When John Glenn was asked what went through his mind as he was about to become the first American in space, he said, "My thoughts seconds before lift-off were: 'Every job in this project went to the lowest bidder.'" I have told this story to many audiences, and they have usually responded with a long and thoughtful silence, followed by nervous laughter. Could this be the epitaph we write for nature? It will be if we keep selling our resources off to the lowest bidder. The only way to avoid this unhappy outcome is to invest in practices and technologies that will protect our natural inheritance, even though they cost more.

Certain older societies read bones to predict the future. If we could see the skeletons of the millions of sea creatures that have died unnecessarily in modern times, those bones would tell a

chilling tale of our present and our future. Picture the newly dead that are drifting down through the blue ocean at this very moment, dying before their time and settling on the ocean floor. What will later generations say when they learn about that panoply of life, lying wasted at the bottom of the sea?

The Grapes of La Mancha

We had come to the legendary land of Don Quixote in quest of
birds. Instead, like Cervantes' hero, we found ourselves tilting
at windmills. Birgit and I aren't really "list hounds" – birders
who try to add as many new species as possible to their lifelong
tally – but we were keeping a record, and in this bleak landscape
of the Spanish interior birds were becoming more difficult to
find. It made listing almost an act of defiance. La Mancha has
never been a verdant place, at least not in its recorded history,
and since mediaeval times, it has been a region of subsistence
farms and small villages. But as we travelled along, we won-
dered how people could survive there. The farms appeared to
have been pounded into the ground by the heavy sun. Every-
where we looked, the land was sere and lifeless.

Then, suddenly, we came upon a vineyard, its neat rows
clothing the rolling landscape, its vines dripping with ripening
grapes. But the place was no oasis, and the grapes were grow-
ing where grapes don't belong.

Vineyards have been flourishing in countries all around the Mediterranean for thousands of years, but evidently this was not good enough for the patrons of Progress. Somewhere in the bureaucratic bowels of Brussels, someone decided it would be a good idea to "help" Spain by growing grapes in a place where nature never intended them to be. The technocrats assured everyone that they had the technology to build very deep wells and expensive pumping systems.

And so it came to pass that grapes were planted in La Mancha. They grew, however, at an unseen price. After the vineyard was established and its deep wells were dug, the shallower wells in the district went dry, and many family farms had to be abandoned.

Before long, more water was needed, and a nearby wetland became the next victim. No matter that the marsh was a paradise for birds and had been designated internationally significant under the Ramsar Convention. It was drained, and the birds fled.

With sufficient water, the vines grew. After some years, the first grape crop was harvested, and the grapes were turned into wine. However, there was a surplus on the market, so the wine was converted into industrial alcohol. But industrial alcohol

was also in oversupply – and that is how the new product ended up in storage. All of these things – the abandoned farms, the ruined wetland, the useless industrial alcohol – were created at taxpayers' expense.

The story sounds like a parable, but it's true. Writ large, it is the tale of modern industrial agriculture. The phenomenon is devastating the planet, and you and I are paying for it.

Here's another account, much shorter. I once painted a picture of an apple tree that was growing on my property. It was done in the fall, so the apples were at the red peak of ripeness. But they were also covered with spots because I didn't spray my apple tree with pesticides.

I often show this picture – *Cardinal and Wild Apples* – when I do slide talks, and then I ask, "Would you eat apples with spots on them and maybe even pay more for them if no poison was sprayed on them? If your answer is no, I have news for you. Spots won't hurt you. If you close your eyes, you won't even know they're there. My grandmother ate spotted apples all her life, and she didn't die from apple spot disease."

We do, however, know that in large doses, pesticides can kill, and we speculate that in low doses, they will kill over a

long time. They certainly destroy huge numbers of beneficial insects and other invertebrates – often predators of the target pests – along with their intended victims. In the last half-century of spraying pesticides, we have not eradicated one pest, but we have bred many stronger ones. It seems that nature can change its spots faster than we can develop new poisons.

Billions and billions of taxpayers' dollars are spent annually on industrial agriculture, and most of that money goes to destroy nature. Clearing away native grasslands and native forests, depleting aquifers and rivers, and spreading deadly chemicals are all part of the package – but nature does not lend itself to industrial application.

The Great Plains of North America once supported an incredibly rich grassland, populated by an amazing diversity of animals, from bison to grizzly bears to swift foxes and prairie dogs. Now these species are either gone completely or reduced to tiny, threatened communities. In place of the diverse richness of the grassland, a few species dominate.

Because industrial agriculture relies on fewer and fewer seed varieties, the great genetic storehouse accumulated over thousands of years of traditional agriculture is becoming emptier and emptier. You need only look in the produce

section of your supermarket to see what I mean. For example, North Americans used to be able to enjoy literally hundreds of varieties of apples. Now we are down to a handful. Most worrying of all, the seeds that could bring back these old varieties are increasingly rare.

Nature is messy and unpredictable. Industrial agriculture is neat and orderly. Natural systems are complex and interconnected, and they have built-in mechanisms for self-preservation. Monocultures are simple and vulnerable – a single pest or bout of bad weather can obliterate them.

Each generation faces the age-old question "How does your garden grow?" The answer we must give is this: "Our garden is growing so fast that it's in danger of destroying the planet." At times, those of us who oppose the gargantua that is industrial agriculture may feel like Don Quixote, waving our lances at huge, implacable windmills, whose great sails keep turning and turning in spite of our most valiant efforts. But we need to fight on. We must grow our gardens differently – and it would be a good idea to think twice before we plant any more grapes in La Mancha.

If a Tree Falls

If a tree falls in the forest, who will hear it fall? More creatures than you can possibly imagine. In the forest itself – the tree's immediate neighbourhood – millions of individual living things will hear, or at least feel, the crash, and each tree that falls changes their world forever. Beyond the forest, the sound will be noticed by many others – the thousands of people who are paying attention to our forests and worrying about their fate. Some live so far away that you might wonder why they care, but they know there is reason for concern.

Most logging companies hope no one will hear about the trees they are felling until it's too late for people to interfere. But more and more often, the word is getting out.

One day in the late 1980s, a naturalist hiking on public land in a rugged part of western Vancouver Island came upon a magnificent temperate rainforest. He measured some of the trees and was amazed by their girth. (They also turned out to be the largest Sitka spruce in the world.) While the naturalist

was taking the measurements, he heard the whine of chainsaws in the distance and the sound of crashing trunks and branches – and that's how the world began to hear about the threat to the South Carmanah Forest.

The British Columbia environmental community sprang into action, spreading the word across the country and around the globe. The activists built a trail to the grove of giants along the Carmanah River, and they invited artists to come and paint the glory of the forest. Then the journalists started flocking to the Carmanah Valley. The logging company was horrified and accelerated the cutting schedule.

I was one of nearly a hundred invited to come and paint the trees. With a group of other artists, I approached the valley on foot along the logging road. As we came near the place, I was stopped short by the sight of a log lying beside the road. It was the biggest one I'd ever seen – at least twelve feet through. As I stood there, my hand resting on its bark, I thought of its past: it had been an old tree when Christopher Columbus came to America. Then I thought about its future. The best I could see for this particular Sitka spruce was an afterlife as a bunch of two-by-fours, or perhaps a stack of junk mail.

Don't mistake my message here. I'm not opposed to

forestry. I believe the harvesting of wood is an important activity – one that can provide many people with meaningful work without destroying our forests. I am in favour of logging and loggers and especially of logging communities. But sustainable forestry means treating each tree wisely and with respect. Unfortunately, this is not the way we in North America take care of most of our trees – and it's not the way we and others treat the fast-disappearing forests of the tropical world.

On this continent, and certainly in my home province of British Columbia, we will have to change our ways drastically if there is to be a future for woodlands and for logging jobs. Some say that supporters of sustainable forestry are committing "job blackmail," but the opposite is closer to the truth.

During the 1980s, while the volume of cut went up in North America, the number of logging jobs went down. The giant forest product companies borrowed money and received generous government grants so they could make huge capital investments in new machinery, sawmills, roads and other infrastructure – the "boys with toys" phenomenon. It's always fun to spend other people's money, especially when you use it to buy machines like the huge tree-harvesting contraptions that

have increased the rate of cut so dramatically in recent years. So governments, businesses and local communities went at the spending spree with considerable enthusiasm.

Such an industrial approach to logging reduces the forest to conventional ideas of dollars and cents, to return-on-investment calculations that ignore the environmental costs. But this is not nature's way of accounting – it never has been. And sooner or later, nature's bottom line catches up with the corporate number crunchers. Ever since the overcutting and overproduction of the 1980s, there has been serious trouble in North America's forests: trouble with wood supply, trouble paying the bills, trouble in the minds of the countless people who care about the diminishing supply of trees and, most telling of all, trouble among forest workers, who keep losing jobs.

Canada now holds the world record for sustaining the least number of jobs per cubic metre of wood cut. The United States generates twice as many jobs per cubic metre, and in Switzerland, there are ten jobs for every one in Canada. Would a higher job-per-log ratio raise the price of wood? In the short run, yes. But the alternative is to deplete the forests beyond sustainable levels and thus put jobs in long-term jeopardy. That is more than we can afford.

My fellow artists and I continued past the fallen Sitka giant until we entered a natural cathedral like none I've ever encountered before — a forest so old that the trunks of its trees rose like colossal pillars separated by wide spaces. I set up my easel within earshot of the clear, rushing Carmanah River, then tried to capture in paint the mossy trunks and the spirit-filled emptiness between them.

While I painted, I began to be aware of a noise competing with the sound of the river. It might have been the faint irritating whine of mosquitoes, except that there were no biting insects in this blissful place. I tried to ignore the buzzing, but I knew what it was and what it represented: chainsaws at work a kilometre away. Every so often, the drone would stop, but that was only a prelude to the sound of a great tree crashing to the forest floor.

For some reason, these Carmanah silences reminded me of listening to the radio when I was a teenager during World War II. In broadcasts about the London blitz, you would hear the German buzz bombs flying overhead, followed by an ominous silence as their motors cut off just before the explosion.

Who hears the sound of a tree falling in the forest? In this case, enough people to make a difference. The art we made

that day became part of a best-selling book, the proceeds from which were used to fight the chainsaws. The publication and the publicity put an end to the logging and led to the protection of the trees of South Carmanah.

A Village Story

At first it seemed like every other morning in the small Mexican village far from the capital. A rooster crowed in the predawn darkness, then a few others joined the impromptu chorus. A late owl gave its last hoot, and the first songbirds sent out a few tentative twitters. Smoke from kitchen fires began to sprawl across the village roofs, and quiet voices joined the clank of pots and pans and the slap, slap, slap of the women's hands as they made tortillas. The men were checking their work tools – shovels, hoes and machetes. Today, they would clear a piece of land that had lain fallow for a few years and prepare it for a crop of corn and beans.

But there was something unusual about the day. The dogs seemed to know it: their barking was a serious and disturbing chorus, not the usual sporadic morning bickering. Then came the sound of machines and the smell of diesel fumes. Finally, the equipment itself appeared: massive yellow monsters emerging with a roar from the scrawny road leading to the

village. It was little more than a track, really, and few cars had ever ventured along it.

The villagers pleaded for the machines to stop, but the banana trees went down, and so did the papayas and even the mango tree, the pride of the village. The men on the machines were just following orders from Mexico City.

Although the villagers and their ancestors had lived and worked on this land since ancient times, it was not officially theirs. In a process they had never known about, the government had come to own it. Then the title to the land wound up in the hands of a retired general, who made a deal with a multi-national corporation to turn the place into a commercial plantation, to grow the sisal used to make rope and twine. The new owner wanted more income from his land than his subsistence tenants could provide with their pathetic rents.

This story happened a few years ago, when the market for sisal was good. It was generally thought that the most efficient way to grow the crop was *en masse*, leaving no room for gardens, cornfields, bananas or fallow land – and no room, by the way, for the village, which just happened to be in the "wrong place." A new community was built along a straight street lined with tin-roofed, cement-block houses, and the villagers – the

new "employees" of the sisal plantation – lived in these company houses.

Some of the former farmers could now afford television sets, but they could no longer grow their own food. So the company provided a store, owned by a cousin of the general, where products were sold at high prices that ate up most of the villagers' "good" wages. People began to suffer from depression and alcoholism. Family violence and petty crime, previously all but unknown, became common, and before long, most of the young people left for Mexico City, drifting to its massive slums.

Then one day in faraway Hong Kong or Tokyo or New York, someone decided that synthetic fibres had a more promising future than sisal. In a few seconds, a message was tapped into a computer. In a few days, the plantation managers got the word. In a few weeks, the plantation was closed down, and the village labourers were fired.

As for the land, no one knew what would happen to it. Perhaps, when market conditions were right, another plantation crop would be grown there. Perhaps it would be subdivided and sold. And what of the villagers? They were left to fend for themselves.

The story of the Mexican village is being repeated countless times in different forms every day all around the world. It is the ancient saga of landlord and serf, with one major difference. The landlords are no longer aristocrats charged with protecting their peasants' interests. Many of them are multinational corporations whose long-distance decisions can wipe out fields, homes and livelihoods in weeks.

The farmers became labourers. The children became slum dwellers. The women watched as their families drifted away. And the plantation that destroyed their community lies lifeless in the sun, waiting for a resurrection that may never come.

This new chapter in the tale of tenant exploitation began in the 1960s, when the eleven main oil-exporting nations formed the Organization of Petroleum Exporting Countries (OPEC). Because they controlled the price of oil, producers' profits eventually skyrocketed and they invested in gold, which they stashed away in the big banks of the industrial world. Of course, the banks wouldn't let all that wealth just sit there without bringing in an income, so they lent large sums of it to developing countries with what they thought were implicit guarantees from the World Bank and the International Monetary Fund

(IMF) that those institutions would help recover the money if the loans were not paid back in full.

On the surface, this looked like a great benefit. Developing nations, thrown off balance by the oil price increases of the early seventies, were eager to improve their situation and welcomed the infusion of money from some of the richest people and institutions in the world. It seemed too good to be true.

And it was – for the money was being thrown around with little thought of the consequences. Local politicians and agents siphoned off their "share" of the funds, and the rest was used to finance megaprojects like the sisal plantation in Mexico.

The point of the exercise was supposedly to produce vast quantities of exportable commodities so the developing countries could pay back their loans using foreign currency. But most of the loans were not repaid. (Often enough, the loan money and foreign currency were used to buy arms, or country villas for the developing nations' power elites.) Most ordinary people derived no benefit from the arrangement: many, like the Mexican villagers, were displaced, and when the loans began to go into default, the IMF required the debtor countries to adopt austere economic policies to make sure at least some of the money was recouped. Everyone but the most privileged in

the developing world suffered greatly. The financial moguls called it "debt restructuring"; the result was devastation.

All of this was brought to the developing world by the most prosperous countries on Earth. As Canadian economist Patricia Adams writes in her book *Odious Debts*, quoting UNICEF, "It is hardly too brutal an oversimplification to say that the rich got the loans and the poor got the debts."

The poor are still reeling from the negative side effects of these misdirected investments.

Homo sapiens Teenager consumerensis

For the last few decades, we have been conducting an interesting social experiment in North America, Western Europe and other "developed" parts of the world: the creation of a new variety of human being, which I call *Homo sapiens Teenager consumerensis*. This new subspecies is not yet universal and was still quite rare when I taught high school, but its numbers are rising fast. The subspecies first began to appear in the boom years of the 1950s, fostered by the arrival of television. Pioneering TV advertisers soon discovered that they could train teenagers to have special needs: special foods, special beverages, special clothing, special music, special movies.

So successful was this strategy that the advertisers soon broadened their targets to include pre-teens and post-teens. They have now persuaded eight-year-olds that they are already teenagers and twenty-five-year-olds that they are still adolescents. Through the miracle of television advertising, these human beings have been fine-tuned into market "targets."

For the first time in the history of humanity, the most vital, active years of a person's growing life are dedicated to one major goal: self-indulgence, encouraged by overexposure to TV. (North American children spend more hours a week watching TV than attending school.) Many people lament the sorry state of youth today, but few, if any, discuss the root problems. It's time we did.

Fortunately, there are many teenagers who have not mutated into this new subspecies. I still meet numerous members of the upcoming generation who are curious, intellectually engaged and socially aware. But those who have succumbed to the commercial forces of TV and other media are being trained to worship consumer products, celebrate sex without love and blow away their troubles with bullets. North American movie and cartoon heroes win through physical force. Advertisers push hot buttons: greed, lust and having fun with violence. Is it so surprising, then, that some young viewers go on shooting sprees, abuse drugs and alcohol or commit suicide? Could this explain many of the problems that are especially pronounced in our society?

Ironically, many corporate conservatives are encouraging unbounded liberty – in direct contradiction to one of the

greatest of conservative philosophers, Edmund Burke. In the eighteenth century, he wrote that people are "qualified for liberty in exact proportion to their disposition to put moral chains on their own appetites" But corporations, through their advertising campaigns, are goading teenagers to go beyond the limits of self-discipline and self-respect, turning them into mere consuming machines.

A frightening question has been occurring to me recently. Could it be that the whole developed world has been conditioned to become selfish and apathetic? Commercials directed at the young seem to make good business sense, but in the long run, an economy based on self-gratification may even eat away at the edges of democracy. Young people who are conditioned to amass wealth in order to fulfill selfish goals will become easy prey for politicians who promote individual prosperity at the expense of community spirit. At the very least, the cultivation of instant gratification will deplete one of our most important resources – the courage, spontaneity and creativity of a whole new generation.

Small Is Beautiful

The year 1998 marked the twenty-fifth anniversary of the publication of *Small Is Beautiful*, the influential book by British economist E.F. Schumacher. To celebrate the anniversary, the publishers reissued the book in a format that included remarks from people who were deeply affected when they first read Schumacher's work and who still admire the author's main goals. I was honoured to be among those invited to comment. While some sections deal only with issues specific to Britain in the early 1970s, I believe the book's essential thesis is as profound and pertinent as ever.

Schumacher wrote that there is an optimal size, an appropriately human scale, for every human activity. In an age of globalizaton and mega-merger-mania, human-scale enterprises sometimes appear to be on the losing side of history. However, there is growing evidence that in many areas smaller is better. As a former teacher, I am convinced that smaller schools and smaller class sizes are more effective than larger ones. They

may cost more, but the best things in life, including a good education, are never free. Smaller communities and smaller companies can be more efficient and more humane at the same time – as long as they are not crushed by political and economic bullies. Smaller bureaucracies, both government and corporate, can also be more efficient and humane.

By safeguarding natural resources and by operating at an appropriate scale, we will produce an important side effect: the developing world will approach levels of self-sufficiency that no foreign aid program could ever replicate. Too often, as Schumacher points out, the developed nations intrude with multi-thousand-dollar, bigger-is-better technology, destroying the developing nation's way of life and rendering ordinary people more desperate and helpless than ever. Replacing their traditional skill and wisdom, the strange new methods destroy their sense of self-worth.

However, they do need technological help. For example, cooking with wood is destroying forests and causing respiratory disease. The average village woman in India inhales the equivalent of many packs of cigarette smoke a day.

The best foreign aid, Schumacher tells us, comes in the form of ten-dollar to one-hundred-dollar technology, which

builds on self-sufficiency and indigenous skills. By funding simple devices like solar cookers, wind or photovoltaic power-generating systems and other sustainable technologies, we would be providing a much-needed antidote to the wasted money and harmful practices of large-scale lending institutions.

A quarter-century after the publication of Schumacher's famous book, his ideas may at last be permeating the ground-water of global thinking. Even the giant automobile manufac-turers are shifting their research toward more durable vehicles, which run on very small amounts of fossil fuel. In Schumacher's words, such developments hold out "the possibility of evolving a new life-style, with new methods of production and new pat-terns of consumption: a life-style based on permanence."

Unholy Alliance

In his last speech before retiring as U.S. president, Dwight D. Eisenhower warned of the growing alliance between industrialists and the military – the so-called military-industrial complex. As one of the greatest wartime heroes of the twentieth century and a leader who had presided over unprecedented boom years in his country, his words were surprising then – but their wisdom is becoming apparent now. Since World War II ended, governments around the world have generated billions of dollars in profits for arms manufacturers – a sweet alliance for the industrialists, a deadly legacy for victims of war around the world. Many would argue that the money has been well spent – defending political interests and foreign investments. Many others would counter that this enterprise has caused untold misery, that any good it has brought about has been far outweighed by unnecessary destruction and pain. They would remind us that at least 50 million people have been killed by war since peace broke out in 1945.

The problem of chronic war is compounded by its damaging economic side effects. The alliance of business and military interests has sucked up precious financial resources – capital that could have been invested in community, agricultural or other programs to help the developing world. And these constructive investments might even have prevented many local and regional conflicts.

Although the arms trade represents about 11 percent of world commerce, the military-industrial consortium is only one unholy alliance. An even greater threat to nature and to human welfare may lie in the growing number of links between governments and corporations. Contrary to the claims of many neoconservatives, these high-level connections have nothing to do with private enterprise. In the words of Franklin D. Roosevelt, "They are a private government, regimenting other people's money and other people's lives." Supposedly democratic regimes are cheering on these unaccountable empires. As employment analyst Bruce O'Hara puts it, we have dug ourselves into a deep hole of *over*production and *under*employment. And what advice do the experts in government and business offer to get us out of the hole? Dig deeper. Produce more. Downsize more.

More powerful than individual governments and sovereign nations, this invisible form of "government" is growing fast — at the very time that the power of elected governments is diminishing and governments are converting their public agendas to corporate ones. Departments once charged with protecting the public and the environment are now cooperating with industries that have little regard for public welfare or the natural environment. Some governments and their agencies have been known to refer to their business contacts as "clients."

Research institutions, including universities, are teaming up with large corporations, who see greater control of our education system as a "good investment." And what return do these enterprises expect? Corporations seek paybacks that improve their bottom lines, so they will pressure our educational institutions to set policies that fulfill their purposes. Those who pay the piper call the tune.

The scientists who work for governments or corporations are under siege. If their findings don't fit the profit-motivated agenda, they are gagged and muzzled. Whistle blowers are severly punished. As a result, the public interest and scientific truth are suffering. What we need is whistle-blower protection legislation, as well as openness and transparency.

As more corporations merge and go global, increasing amounts of power will be concentrated in the hands of fewer and fewer decision makers. But apart from the occasional noisy street protest against globalization, opposition to this trend has been rare. North Americans are slipping into a state of political unconsciousness that has taken the spine out of democracy.

In *The Unconscious Civilization*, John Ralston Saul speaks about this collective apathy and argues that the neoconservative movement is really far from conservative. Rather, these ideologues want to take power away from elected officials and put it into the hands of corporations. And the multinationals, as Saul tells us, "have very little to do with capitalism and risk. They are reincarnations of the seventeenth-century royal monopolies." The new corporatism, Saul continues, "denies and undermines the legitimacy of the individual as the citizen in a democracy [and the] particular imbalance of this ideology leads to a worship of self-interest and a denial of the public good." In the end, "the practical effects on the individual are passivity and conformism in the areas that matter and non-conformism in the areas that don't."

In the world of global commerce, words like *loyalty, dedication, honour, devotion* and *sacrifice* are no longer held in high

esteem. Too Victorian, some would say. But these virtues, which were praised in song and conversation during World War II, are still visible in the work of dedicated activists and responsible businesspeople, and they were evident in John F. Kennedy's now-famous inaugural address: "Ask not what your country can do for you," he said, "ask what you can do for your country." But that speech was made almost forty years ago, and now it's more common for public figures to appeal to selfishness, rather than a sense of sacrifice for the greater good.

Since the 1950s, I have watched as the practice of self-interest rose to the level of a science. Vast segments of our population have been trained in self-indulgence, the most overt expression of this phenomenon being the "Me Generation" of the 1980s. Corporations and politicians of the global economy are doing nothing to stem the tide of narcissism. Instead, they are mesmerizing the public with a new set of slogans: *greed, bottom line, windfall profits, downsizing, ruthless competition.* These are the buzzwords of the unholy alliance between business and government.

I think it's time to start changing our vocabulary.

Natural Capitalism

As a kid growing up in Toronto, my favourite drink was water.
In spite of its chlorine bouquet, I drank lots of it – straight
from the taps, of course. In those days, we never thought of
buying the stuff in bottles. After all, we lived right next to Lake
Ontario, one of the world's largest sources of freshwater.

It was only some years after I moved away from Toronto
that I realized what a complex cocktail I'd been imbibing. In
the 1970s, people living on the shores of Lake Ontario learned
that for years chemical manufacturers in Niagara Falls, New
York, had dumped hundreds of tons of toxic waste into the
nearby Love Canal. Later, the canal was filled in, and houses
and a school were built on top of it.

Then the bad news stories began to emerge. The people
living over the old Love Canal were suffering from kidney
and nervous disorders, among other diseases, and higher-than-
average proportions of birth problems: miscarriages, still births
and birth defects. Tests revealed that much of the area was

extremely toxic, containing dioxins, chloroform and PCBs and numerous other dangerous chemicals. Eventually, the residents were evacuated, their homes were purchased by the U.S. government and the school was closed. A fence was put up around the place. A sign warned outsiders that it was a hazardous area.

But the fence couldn't hold in all the chemicals. The sedimentary rock of the Niagara region is laced with cracks, seams and fissures, and the Love Canal's deadly broth had been leaking through them for years – into the Niagara River and on into Lake Ontario.

Toxins like these, along with animal waste from industrial agriculture operations, pose a great health risk. Among the 350 manufactured toxic chemicals that have been identified in the Great Lakes, many stay in the environment for a long time – including carcinogenic dioxins and furans. Birth defects, immune suppression and cancer have all been associated with the damaging chemicals in our water.

Some claim that the diseases and death connected with the industrial by-products we have added to our environment are unavoidable in a healthy economy. But pollution is a lose-lose situation. The contaminants in our air, water and food are

costing us millions through lost productivity, hospital-care expenses and premature deaths.

Those who say the price of pollution should not be measured in dollars and cents fail to value "natural capital," the sum total of the natural resources and biological support systems of the planet. The most notorious practitioners of such old-style economics are the government statisticians who measure a country's annual gross domestic product, or GDP. According to their value system, the only transactions to be factored into a country's economic "product" are ones that cause money to change hands. Recently, Canada's big-business lobby group, the Business Council on National Issues, was still arguing that GDP is a true measure of our standard of living.

Yet the GDP fails to count some of our most important "products," completely omitting the underground economy and ignoring the unpaid work of the household and volunteer sectors. At the same time, it places a positive value on items that cause ecological damage. Our GDP goes up whether we spend a million dollars planting trees or installing smokestack scrubbers on the local coal-fired power plant or whether we spend the same amount cutting down a forest or paving over

acres of productive farmland. Building high-polluting gas guzzlers makes just as much economic sense as manufacturing low-polluting, energy-efficient cars, buses and trains. Every oil spill, like the infamous *Exxon Valdez* disaster, every cancer case and every imprisoned criminal translates into a positive score according to the GDP's illogical measure.

The madness of this way of thinking is compounded by its most far-reaching side effect: the devaluation of human beings and the work they do. Since the beginning of the Industrial Revolution, capitalism has given those of us lucky enough to live in the West a great deal more convenience and a multitude of creature comforts, but it has also given us less and less meaningful work. Worse still, to a growing number, it has given very little work or no work at all. The trouble with unbridled capitalism is that the planet can't sustain it. If you run out of fish, the most sophisticated factory ship won't catch you any. If you run out of trees, the biggest and niftiest tree-harvesting machine will be left by the side of the logging road to rust.

For business, the most fundamental value shift will be away from an obsession with labour efficiency to what Paul Hawken, Amory Lovins and L. Hunter Lovins call resource productivity,

in their recent book *Natural Capitalism*. Instead of trying to save money by using fewer people, businesses will cut costs by using resources – raw material and energy – more efficiently. Hawken says the shift is already well underway, even in some of the world's largest companies.

The sooner we change our thinking as a society, the more quickly natural capitalism will displace old-style capitalism. The shift in values is simple and profound: value the goods of nature, treat them as precious capital worth preserving. Value beauty, durability and humanity over short-term profit, the fast buck, the quick fix. Value the future, as well as the present.

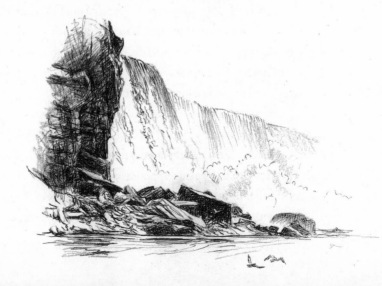

Beyond the Rapids

At university, I majored in geography, but I never stopped working at my art. After I began teaching, I used to say that I taught for fun but painted for real. All the same, I knew that art and geography have much in common: they are both about shapes and patterns in space. It has been my good fortune to be able to explore these patterns in every aspect of my life: as a naturalist, as a teacher of geography and art, and as a practising artist.

In painting, part of my task is to sort out forms and light, to look for the patterns that will best represent the reality I am trying to portray. I accept some shapes and reject others; I choose angles and focus on a long or short view.

Over the years, I have also observed changes in the patterns of North American values. The frugality and hardship of the Depression years were replaced with the heroism and anxiety of wartime, and the postwar boom brought unbridled optimism and a belief in Progress – a notion that, in retrospect, had more to do with materialism and self-advancement than with building

a sophisticated and compassionate society. By the early 1960s, it was clear that our carefree approach to industrial development and urbanization was not working. DDT-ravaged peregrine falcons were laying eggs with shells so thin that the young never hatched, and our love affair with the internal combustion engine was going sour. Urban sprawl was eating up the best farmland and wildlands in North America.

Since then, we have alternated between gloom, denial and many brilliant demonstrations of profound care for the natural world: laws restricting DDT use were passed in Canada and the U.S. in the early 1970s, and peregrines began nesting successfully on the sheer faces of city skyscrapers. In 1995, the British Columbia government announced that lumbering in the forest of Clayoquot Sound on the Western coast of Vancouver Island would be permanently halted. In New Jersey, Governor Christine Todd Whitman proposed a ten-year plan to save a million acres of farms and open space forever. Like painters, we were being challenged to choose new shapes and patterns by which to live our lives.

In my geography studies, I learned about the two main philosophies that underlie the geographical sciences: determinism

and possibilism. Determinists believe that fate and circumstance dictate the course of your life, and there is nothing you can do to change it. Possibilists believe that no matter what your circumstances, you can alter the direction your life is taking. There are always choices, an infinite number of possibilities.

I am a possibilist.

I believe that humanity is master of its own fate. I believe that the human spirit and human ingenuity are capable of creating a complex variety of possibilities from any given set of circumstances. I believe that as individuals we have choices. And since a society is neither more nor less than the sum of countless individuals making infinite individual choices, we have options as a society.

North America, like the rest of the world, is going through turbulent times. It is as if we are in a canoe that has hit rapids — and there's rough water ahead as far as the eye can see. We have the choice to steer or not to steer, but we do not have the option of getting out of the canoe. We might even paddle to one side and hold in an eddy while we look ahead and challenge many of the assumptions underlying our present philosophy — assumptions like bigger is better, you can't stop Progress, no speed is too fast, globalization is good. We have

to replace these notions with some different beliefs: small is beautiful, roots and traditions are worth preserving, variety is the spice of life, the only work worth doing is meaningful work, biodiversity is the necessary precondition for human survival.

It's into this philosophical channel that we need to steer our canoe – toward a good future for all life on Earth. If we change direction in time, we will get beyond the rapids.

PART THREE

Signs of Hope

We have lived by the assumption that what was good for us was good for the world. We have been wrong. We must change our lives, so that it will be possible to live by the contrary assumption that what is good for the world will be good for us.

Wendell Berry

The real problems of our planet are not economic or technical, they are philosophical. The philosophy of unbridled materialism is now being challenged by events.

E.F. Schumacher

Let no day pass without discussing goodness.

Socrates

An Alpine Idea

There is a place in the Alps that thinks like a mountain. I could name it, but I don't want to – the community is not unique in that area. It represents a general attitude toward the world from which everyone could learn, for its success is philosophical more than economic or technological. Towns, villages and countryside share an attitude that could be summed up in a single word, *respect* – respect for the land, for nature, for grandparents, for grandchildren, for the past and for the future. Our family lived for a year in a two-century-old farmhouse in that part of the world, and during our stay there, we learned a lot.

I would often take rides on my mountain bike, roaming a network of trails that wound through farm and forest, all on private land, and I never saw a "keep out" or "no trespassing" sign. There was no evidence of vandalism and virtually no littering. Everywhere I went, the word *respect* came to mind.

I took a postcard-like photo that year. The background is a rim of mountains with some snowy peaks showing through the

clouds. The steep slopes are clad in dark green forests; the flat land is covered with crops, pastures and gardens. Alpine farm houses are sprinkled here and there. The village is a tight cluster of about two hundred houses, dominated by a single baroque church spire.

There are new houses in the village, but they are all built in the regional style, so it is difficult to distinguish them from the older homes. The farms are all family operations, which are doing very well, with the help of government subsidies. European society believes in supporting family farms – unlike North American society, which encourages industrial agriculture.

The dark green slopes will be logged sooner or later, but as in the past, this activity will unfold according to a thoughtful plan. In the picture I'm describing, you can see a very steep clearcut, about one hundred feet wide and several hundred feet long. The local loggers use modern technology to take a cable by helicopter from a spar tree at the bottom to one at the top. All the logs are brought out by air, leaving the mosses and seedlings of the forest floor unscathed. Parent trees spread seeds from the local gene pool, so there is no need to replant, since nature does all the work. The trees are converted to lumber at the village sawmill, and the lumber is used at the local

furniture factory to manufacture alpine-style products, keeping the wood-processing jobs in the community. At the head of the valley, you can also see a medium-scale hydro plant – and a moderate-sized downhill ski development perches higher up in the mountains.

One especially interesting part of this picture, however, cannot be seen in a photograph – the hunting. The valley teems with wildlife, and this has been turned to a major advantage for the valley's economy. Locals can shoot game birds and rabbits, but red deer (similar to our elk) and chamois (like nimble mountain goats) are reserved for hunters who pay. Every seven years, the exclusive lease goes up for bids. The last successful bidder was a German prince; the present one is a multinational corporation, which is paying hundreds of thousands of dollars per year for the exclusive right to hunt big game.

During our stay in the area, our family went game viewing and photographing in each of the four seasons. Our guide was Fritz, the game warden, who is responsible for keeping the wildlife healthy, guiding hunters and making sure all visitors stick to the rules.

Fritz is a game warden with a hands-on task. Let's imagine it is fall, in hunting season. Fritz is leading a small party of

business executives. A particular vice-president has been given the chance to bag a male red deer as his reward for signing a deal. It is a beautiful day, but the hunting has been poor. It is four o'clock, and the executive has a plane to catch. Suddenly, a magnificent buck walks into a glade in front of the group. The vice-president raises his gun to shoot. Fritz takes one look at the animal and says, "*Nein!* You can't shoot that one!" Fritz knows this particular animal. He knows its mother, its father, its whole lineage, going back many generations. He knows that its excellent genes are needed for at least four more years of breeding. When its antlers grow larger, it will make a good photo in the hunting journals – which might bring in more money for the community.

The scenario that follows happens in seconds, with no time for explanations. The businessman takes aim, but Fritz is ready. He knocks the man's gun in the air and fires off his own to scare the deer away. In the domain of the forest, Fritz is king. His father and grandfather before him were the wildlife wardens, and he hopes his own son will follow him. Fritz's boss, the chief forester, is the most respected man in the region. Everything in the forest is done for the good of the community and its future.

A few years ago, we met the wife of the chief forester for dinner in Salzburg. During the meal, I speculated that if a photographer came back fifty years later and stood in the spot where I had taken the postcard-like picture, the photo would be the same. The forester's wife tilted her head to one side, smiled and said, "Yes, I think you are right. It will be the same picture because we like it this way. We think that our little valley and community are very nice. We will get computers and fax machines and fine tune our lives, but we will hold onto our values."

Are these revolutionary ideas? Are the inhabitants of this valley living in the past or pointing the way to the future? For me, their way of living offers reason for hope.

The Grameen Bank

Already the women were gathering, even though the van was not expected before early afternoon. To avoid the midmorning sun, they were sitting in the shade of the thatched porch, with an immaculately swept dirt floor. The few objects visible were handmade: a large basket in the shape of a disc, used for winnowing grain, black and brown earthenware pots glowing against the smooth yellow-grey clay of the walls, which in places had been formed into shelves for the smaller vessels. A red chicken clucked and complained at their feet. A dwarf brown and black goat grudgingly gave up his place in the shade to make room for more arrivals. Soon, the porch was crowded with women clad in colourful saris.

It was an important day for the woman of the house. She was about to make a business deal. The approaching van was a branch of the itinerant Grameen Bank.

This bank is the brilliant idea of Muhammad Yunus, a professor of economics at the University of Chittagong. Its

mission is to put money into the hands of Bangladeshi women through small loans. To obtain one of these loans, a woman with a good business idea needs no collateral – only the support of a group of her "sisters," other women in the village. With this small amount of money, the woman can invest in a goat or a loom or anything that might generate income and help the family take one small step up the economic scale. (The trick is to keep the cash in the hands of the women because many of the husbands waste the money they earn.)

The work of the Grameen Bank may seem like small potatoes, but multiplied by tens of thousands of loans, the Grameen Bank and others like it are making an enormous difference at the grass roots, where it really counts. One that's making a difference closer to home is Oregon's ShoreBank Pacific, a commercial bank that specializes in community development and environmental restoration. This bank has lent millions of dollars to smaller enterprises that practise sound environmental management or adopt policies that enhance social equity.

The Grameen Bank has a far better repayment record than the Chase Manhattan Bank – far better still than the international financial groups that lend billions of dollars to fund megaprojects in developing countries. These loans are so high

that they burden borrowers with loans they can never repay. Even a small fraction of the amount that has been loaned for huge projects like the Three Gorges Dam on China's Yangtze River would do more good if it was divided into small quantities and offered to people like these women in Bangladesh, who won't waste a penny.

Children shouted and ran ahead of the cloud of dust that announced the arrival of the Grameen Bank's van. The searing sun and heat were forgotten in the jubilation over the deal that was about to be made. The bank's representative stepped out of the van and approached the women gathered in front of the house. It was a transaction involving the whole group, but to the woman receiving the loan, the future looked brighter than it had a year before.

Nigerian Public Transit

The year was 1963, the place southeastern Nigeria – Iboland –
and I needed to get to Port Harcourt, the nearest settlement of
any size. As a newly arrived teacher at Government College
outside the small town of Umuahia, I was a bit apprehensive.
I'd been hired on a two-year contract to teach geography to
Nigerian boys preparing for college entrance exams, but first,
I had to set up a new home. So I was heading for the port city
to pick up my household goods, which had been shipped from
Canada by sea.

A fellow teacher had driven me into town to catch a taxi.
As usual, the taxi park, a rutted and dusty acre of dirt, was
bustling, and I was deluged by a lively array of sounds and
sights and smells. Another Canadian I'd met – he taught
English in a nearby town – compared Eastern Nigeria in the
early 1960s to Elizabethan England: lusty, complex, disor
ganized and ebullient. All these words seemed apt as I moved
through the sea of noise and colour, acutely aware of my pale

complexion. Everywhere I looked, it seemed that everyone wanted to address me, to query, cajole or coax me into their taxis in language I barely understood. But I could see little difference between one decrepit five-passenger sedan and the next.

My colleague had explained to me that each taxi would wait until seven or eight people were packed in, and then head toward various points of the compass. The trick, he'd said, was to pick a Port Harcourt-bound cab that was already almost full. If I climbed into an empty cab, he warned, I might have to wait quite a while until the driver had lured a full load into the vehicle. A driver might even kick a person out at the last minute if passengers interested in a more lucrative destination turned up. And being the last to squeeze in gave you the added advantage of sitting beside an open window.

I made my choice and jumped in.

Off we went in a cloud of exhaust fumes, bouncing and weaving the seventy-five miles to Port Harcourt. Along the route, we played countless games of chicken with oncoming trucks and dodged throngs of colourfully clad pedestrians. I noticed that the roadsides were tidy and litter free, and the villages were picturesque and immaculate.

Ironically, the fossil fuel that powered that cab and billions

of vehicles around the world caused the demise of Nigerian society as I knew it in the sixties. By the next decade, the Nigerian oil boom had brought wealth to a few but ruined the country as a whole. A wonderful way of life was lost.

Before the boom, there was a scarcity of consumer goods, so local entrepreneurs had created an efficient recycling system: bottles and plastic bags were put to use or sold for a few pennies in the local market. Every scrap of paper was kept, to help start the cooking fires. This subsistence lifestyle was not easy, but it was efficient because little went to waste. And though life in Nigeria may not have been smooth in North American terms, it was full and satisfying.

Nigerian public transit wouldn't sell in North America. But our current version of mass private transit isn't working either. Highways around most urban centres are congested, especially at peak hours, and single-occupant vehicles are major sources of smog-producing emissions, emitting one-quarter of North American greenhouse gases. Some claim that an investment in clean, attractive public transit would be a drain on the economy, forgetting that the taxes motorists pay don't begin to cover the costs of building and maintaining roads and parking spaces.

And automobiles remain among our most wasteful creations, burning 450 U.S. gallons of oil per person every year and annually creating more than 7 billion pounds of waste, including potentially recyclable scrap metal.

Despite remarkable gains in the efficiency and cleanliness of the internal combustion engine, the automobile continues to be an extremely wasteful machine. According to Paul Hawken and the other authors of the book *Natural Capitalism*, motor vehicles lose at least 80 percent of the energy in the fuel they consume — mainly in the engine's heat and exhaust. Every year, American cars burn their own weight in gasoline.

Yet there are hopeful signs: cars that run on a hybrid-electric propulsion system like the one used in the ultralight, ultra-low-drag Hypercar design is one. Vehicles manufactured according to this design, developed by the Hypercar Center of the Rocky Mountain Institute, will consume only one-third of the fuel of similar, standard automobiles. Interestingly, hybrid-electric propulsion has been around since the early 1900s. It uses an electrical motor to turn the wheels — far more efficient than an internal combustion engine — while a gasoline engine generates the electricity.

The first hybrid-electric-propulsion cars are already on the

market. (Toyota's Prius, for instance, was introduced in Japan in 1998 at an affordable sixteen thousand dollars U.S.). These vehicles promise to be part of a transportation revolution.

I left Nigeria in 1965 and have not returned since, but I keep in touch and I've watched the country's decline with dismay. The oil boom brought corruption and Western-style waste to a vivacious but thrifty society at a time when North Americans were beginning to feel the effects of their own overdependence on fossil fuels.

Perhaps it's time we both went down a new road.

The Ecology of Cities

We were hustling across the cobblestones, our footsteps the first to print the fresh morning snow. It was 8:15 AM on December 25, and the sun was just catching the top of the archbishop's palace. Except for the horses and their drivers, we were the first ones in the square. Birgit and I and a few of the younger generation were rushing to get good seats for Christmas mass at the cathedral. Were our hearts beating faster because of the soul-filling sound of the church bells? Or was it simply the joy of being surrounded by family in this place, this ancient and civilized place, which was so intimate and welcoming that we already felt a part of it after only a few days?

Of all the crazy projects I've tried, perhaps the most delightful was to spend the Christmas season of 1999 in Salzburg with the whole family, I mean the *whole* family – all my immediate relatives and all of Birgit's, ranging from her mother to our four grandchildren. The city of Salzburg proved to be the perfect setting for the celebration. It was

neither too big nor too small: big enough to be richly varied and culturally complex, small enough to be human in scale. As we walked along the streets, it was not unusual to round a corner and bump into a cluster of happy relatives. Best of all, in the old town, we could wander on foot without the interference of cars.

In this part of the city, Salzburg resembled a village full of palaces and cathedrals. Off the main squares, cafés and shops hid in a rabbit warren of side streets. The air was filled with the sounds of conversations and street musicians, not the clamour of machines. Roadside food stands offered appetizing smells, unadulterated by exhaust fumes.

Salzburg is not the only community in Western Europe that is supremely liveable as a result of its human scale. Many European nations have grown wiser over the years because both natural resources and space are so obviously limited. Holland, for instance, started with very little resource wealth, land that was subject to flooding or permanently under salt water – and a very soggy climate. But the Dutch built dikes, canals and polders (farmland wrested from the sea) and became a thriving community, marked by great artistic and commercial accomplishment.

Many Dutch communities are also models of ecological balance. The country has preserved and protected natural areas – and even created new ones from some of their polder farmland. Dutch citizens pay additional taxes on cars and refrigerators, which are specifically earmarked for recycling when their usefulness expires. And even in busy Amsterdam, cyclists are given dedicated space on the roadways. Although the country is densely populated, it has large expanses of green spaces that are perfect for birdwatching or bike tours.

Places like Holland and Salzburg have many lessons in living to offer North Americans – compact urban design, balance between city and countryside, and communities where people feel free to walk or cycle. So many North American cities have become dirty, noisy, desolate places to live and work because they've been built or redesigned to accommodate cars and highways, not people. Politicians and planners in these urban centres would benefit from looking at a few European models.

There are exceptions, of course. Look at downtown Toronto, for instance. It is still a city of engaging, human-scale communities – many of them former villages that have retained their village character. This is one of Toronto's great

strengths. And the city's heart has survived so far because of the hard work of enlightened politicians like David Crombie and John Sewell and intelligent activists like Jane Jacobs.

Jacobs arrived on the scene in time to lend her expertise in the famous fight to stop the Spadina Expressway, a four-lane highway that would have cut through established neighbourhoods like a cleaver. I was one of the thousands of Torontonians who joined that fight. Thanks to the sheer power of citizen activism, we won. The Spadina Expressway was never built.

Decision makers and activists in downtown Toronto have also done a fairly good job of preserving the city's architectural heritage – most of it nineteenth-century Victorian – but the demolition of landmarks and other important structures has always been a threat. When Toronto's famous new City Hall was being built, the "you-can't-stop-Progress" types wanted to tear down the gracious and intricate old City Hall and replace it with an office tower. The British sculptor Henry Moore happened to be visiting Toronto at the time, to oversee the installation of his powerful sculpture *The Archer* in the plaza in front of the new City Hall. When he was told of the movement to tear down old City Hall, which formed a backdrop to his sculpture, he exploded. "What are they? Barbarians?" he

replied. Moore saw that his high modernist *Archer* and Toronto's Victorian edifice made for a marvellous, surprising juxtaposition — a symbol of cities at their best.

But even cities as successful as Toronto aren't immmune to the disease called urban sprawl. This disease has many symptoms: two of the most serious are pollution and loss of farms and open space in the urban hinterland. As a city spreads out, more and more automobiles use the roads, and drivers have to travel farther to most destinations. Sprawl also costs more than higher-density development because spread-out housing results in fewer taxpayers per mile of road.

Cities that add low-density development around their borders also consume acres of nearby farmland. It tends to be targetted by developers because the land has already been cleared, and it is usually easier to build on because it is mostly level. Between 1976 and 1996 the Greater Toronto Area alone lost 150,000 acres of farmland to urban sprawl. And Vancouver, the largest urban centre in my part of the world, is rapidly destroying the rich agricultural land of the Fraser River Delta.

Some North American cities are tackling the problem head on, investing in better public transit (instead of sprawl-promoting highways), while adopting policies that encourage

density and discourage inefficient land use. In Portland, Oregon, for example, intensified development and limits on growth have kept the countryside within a twenty-minute drive of downtown. A freeway running along the waterfront has also been torn up to create a park. Seattle offers free daytime public transportation in the downtown area and an extensive suburban transit network, reducing the number of smog-producing cars. At its best, city planning does not attempt to legislate one particular future, but encourages many creative possibilities.

Although I am in many respects a "nature boy," I love cities. The Royal Ontario Museum was my second home as I was growing up in Toronto, and in each city I visit I am always drawn to its great public institutions, its art galleries, theatres and museums. But my favourite urban centres are those where such amenities flourish within thriving neighbourhoods. As Jane Jacobs has pointed out, healthy cities, in their richness, complexity and unpredictability, imitate the variety and com-plexity of nature. These are places where all the activities and "uses" of the urban environment collide and interact. An active city where people feel free to walk creates more "eyes on the

street," and this, in turn, makes for a more secure environment. As in complex ecosystems, complex cities are not only richer than homogenized ones; they are safer for their inhabitants.

Even though many of the world's urban centres now seem to have deteriorated to a point beyond hope, they can be revived if we think of them as complex environments that have a delicate ecology worth nurturing.

Holy Alliances

Birgit and I were making a pilgrimage to one of the snow leopard's last domains. Along with several other members of the International Snow Leopard Trust, we had arrived that day in Kathmandu. In the evening, as we made our way to dinner, the stars shone with a vividness possible only at an elevation of 4,300 feet. But no matter how bright the light by day or night, we would see none of the great and ghostly cats in the wild during our visit. Even the distinguished wildlife biologists George Schaller and Rodney Jackson, who have spent many years studying the snow leopard, have seldom seen one. The next day, however, we did expect to see the leopard's habitat through our binoculars.

Our host for that evening's welcoming dinner was a Nepalese businessman, a patron of the Snow Leopard Trust. One of the guests was an Indian army general, whose jurisdiction was Ladakh, often called India's Tibet. In that region, the majestic cat is close to extinction because of poaching

(the skins and body parts sell for exorbitant prices), because its prey species are being killed off and because domestic animals overgraze much of its territory. (These problems have brought the snow leopard close to extinction in other regions, as well.) Many in our group were at first surprised to encounter a military man at such a gathering. But once we spoke to him, we understood why he'd been invited. The general was a naturalist and a conservationist.

Because Ladakh contains so much of the snow leopard's threatened range, the general had instructed his officers to patrol their territories with the leopard's interests always in mind. To encourage them, his soldiers would win favour through nature protection. They were to act as "eyes on the landscape," looking for poachers and warning villagers who were encroaching on natural areas by extending their pasture lands.

What would happen if every military officer was also a trained naturalist? What difference could this make, especially in Asia, Latin America and Africa?

On another starry night a few years later in a very different place – the State of Israel – we drove at a snail's pace through

a desert wilderness. We were on the lookout for nocturnal animals, above all the sand cat, one of the smallest and cutest wild cats in the world. We saw no wild felines, but we did experience an important moment. We saw a wolf.

This wolf was thin and spooky-looking, walking with its head down. Its eyes glowed eerily in our headlights before it vanished into a conglomerate canyon. We caught only a fleeting glimpse before it vanished, but I'll never forget the sight. I was fifty-seven years old and had been in wolf country many times in my life. I had howled for wolves in Algonquin Park and heard their answering call, but I had never seen one of these creatures in the wild.

That I saw my first noncaptive wolf in Israel is both ironic and instructive. Few people know that the Israelis have done far better than most at protecting, and even restoring, the natural world. Their stated government policy is that every animal mentioned in the Bible – except the lion – should once again roam free in wilderness areas of the country. Many species have already been reintroduced and are now doing well, including the leopard, the wolf, the desert gazelle and the Nubian ibex.

As with the Indian army in Ladakh, in Israel there is a

holy alliance between the military and nature. Israeli military officers are required to be trained naturalists, and part of their job is to protect the 23 percent of Israel's total area set aside as nature reserve. In Israel, the author of this arrangement was General Abraham Jofe, a hero of the Six Day War.

Coalitions like this exist in other countries, as well – broad alliances of wealthy and powerful people with conservationists and environmentalists. King Hussein and Queen Noor of Jordan established a Royal Society for the Conservation of Nature and set up nature preserves in their country. Ted Turner, one of the wealthiest and most powerful businessmen in the world, gave $25 million to grassroots environmental groups in 1998. And he has set up an endangered species fund to involve private landowners in conserving imperilled species like the desert bighorn sheep, the California condor and the black-tailed prairie dog. Canadian industrialist Robert Schad has given millions to environmental causes and has funded successful opposition to Ontario's spring bear hunt, which was condemning orphaned cubs to die of starvation or predation in the northern woods.

Among the many examples of enlightened people of

privilege, however, one in particular stands out in my mind.

We had been invited to one of England's most stately homes for an afternoon reception and meeting one glorious day in June 1990, along with other supporters of Sir Peter Scott's Wildfowl & Wetlands Trust. The house and grounds were elegant, and the only thing missing was our host. We had been informed that he was in the hospital, having fallen off his polo pony and broken his arm, but we were to carry on and enjoy the afternoon anyway. Our missing host was Prince Charles.

I had admired the prince for many decades and had always felt that we were kindred spirits because of our shared interest in nature and painting, and our desire to protect human, as well as natural, heritage. Charles believes that the look of a landscape, whether urban or rural, has a profound effect on the human spirit, influencing mental health, personal behaviour and economic activity.

After the meeting, we explored the grounds and formal gardens beyond the house, where Charles is re-creating the ecosystems of ancient Britain, all but wiped out by modern farming. Nurtured on the estate, native English grasses and flowers thrive once more, supporting communities of rare butterflies and birds.

Charles is becoming a spokesman for a sane alternative to industrial farming, and he takes special pride in the estate's organic garden. As one of *Time* magazine's "Heroes for the Planet," he is showing by example that a gentler, more considered approach to agriculture works well and actually pays.

An Indian general, an Israeli war hero and a king-in-waiting are three signs of hope among many. But you do not have to be a prince or a millionaire to achieve victories for the natural world. Some of the world's most influential environmentalists began their work with nothing but a bright idea – and that took them farther than they may ever have imagined.

From Tortoise Islet

We were sitting around a rickety table made of scrap wood, where we had finished a simple supper. The sunset had turned the surrounding sea to orange, and the ragged silhouettes of the other islets were darkening to black. One of the guests that evening was Bristol Foster, the companion of my round-the-world Land Rover trip back in the late 1950s.

On that journey, Bristol and I had thought about visiting a young English woman we'd heard about, who was about to begin studying chimpanzees in Tanganyika (now Tanzania). But we had abandoned the idea when we learned that the trip would take at least two weeks and we couldn't even be sure the woman would be there when we arrived. That woman was Jane Goodall, and now she was sitting in our cabin on Tortoise Islet, sharing a West Coast sunset and her thoughts about the future of the planet.

The little two-room cabin sits on a one-acre "double hump" – an islet shaped like a tortoise, about fifteen minutes

by boat from our home. We had designed the cabin with patio doors on all four sides, which meant the darkening ocean was all around us, even though we were sitting inside.

Jane had just come from Los Angeles, where she had met with a group of inner-city gang leaders who were working with her on her "Roots and Shoots" program. Through this project, she is bringing a love of nature and animals to some of the children of Africa and the American ghetto.

In Los Angeles, she was also asked to speak at a convention of police chiefs – but only if she would address them first thing in the morning, before their meetings began. That night, she hardly slept for worrying about how to command their attention at such an early hour. The next morning, when this slim woman appeared before them, they barely looked up from shuffling their papers. She decided to try the technique used by a female chimp in getting the attention of a dominant male. She moved right up to the microphone, puckered her lips and, in a high-pitched croon, said, "Woo, woo, woo, woo!" After that, she had their undivided attention.

That night beside the ocean, Jane showed us two of the talismans she carried with her on her travels: a leaf from a tree in Hiroshima, one of the first to come to life after the atomic blast

of 1945. She also showed us a fragment of the Berlin Wall and reminded us how complete was the collapse of the tyranny that the wall represented. Despite the many signs of doom in the world, she prefers to focus on hope.

Some people think of Jane Goodall as a modern-day saint. She must raise tens of thousands of dollars every month to keep her work going and travels extensively in support of her causes. Her life of sacrifice and service is a much-needed antidote to the selfishness and greed that motivate so many leaders. Jane Goodall gives us all reason for hope.

Good People

I am not an early riser, yet there I was at five in the morning in the cold and dark, standing on a gravel road in the Clayoquot forest of western Vancouver Island, feeling guilty about not going to jail. I was one of several hundred people positioned just before the Kennedy Lake Bridge, which led to about 350,000 hectares of superb old-growth forest that was being clearcut at a rapid rate, five days a week. We were there that day in the summer of 1993 to stop the logging trucks from crossing the bridge. A designated few had volunteered to be arrested for the cause. International interest in the issue helped explain why so many newspaper, radio and TV reporters – including a television film crew from Germany – were standing near us that morning.

The night before, at the Clayoquot Peace Camp, we had discussed what we would do if loggers and their families showed up at the protest. Increasingly, actions against irresponsible logging are being countered by media-savvy tactics,

including loggers' wives arriving on the scene with babies in their arms. Understandably, they fear that conservation will cost their husbands their jobs, but they are being used as pawns by the forest product giants.

At the Peace Camp, twenty people volunteered to be peace-keepers, resolved to prevent any violence of deed or word. The feeling in the group was one of respect and quiet determination. I don't use this word often, but *spiritual* is the only way to adequately describe the atmosphere that existed the night before the demonstration. After the peacemakers were confirmed, those who planned to be arrested were asked to raise their hands.

The mood of inner peace persisted as we stood in front of the bridge that chilly morning. We were a varied collection of humanity: children and men and women of all ages, business-people, artists, doctors, musicians, writers, homemakers, scientists, foresters. One grey-haired woman had travelled three thousand miles to be there. The mood was subdued but expectant, interrupted only by occasional low laughter or quiet words.

The forest companies and the government of British Columbia were determined to keep logging operations going in the Clayoquot Lowlands. Although Canada had been among

the first to sign the Biodiversity Convention at the Earth Summit in Rio in 1992, British Columbia's Clayoquot Sound Land Use Decision, announced in the spring of 1993, gave logging companies the right to clearcut a large portion of the area. It protected only about one-third of the Sound.

The protesters at the Kennedy Lake Bridge had an astonishing number of supporters. People outside B.C. had joined the movement, among them Robert Kennedy, Jr., of the Washington-based Natural Resources Defence Council. Teams of Canadian environmentalists had made trips to Germany and Britain, to promote the idea of protecting old-growth Canadian rainforests. The concept caught on like wildfire, and public opinion in Europe forced the cancellation of several contracts to buy Canadian forest products.

This was only the latest in a series of protests aimed at putting a stop to logging in Clayoquot; by now they had taken on the quality of rituals. The government and the logging operations had lost patience with the work stoppages and a court order had been obtained, prohibiting interference with Clayoquot Sound logging operations. To disobey this order was to commit an act of criminal contempt of court, punishable by up to two years in jail.

It was still completely dark when we heard the engines of the approaching trucks. As they had on every previous morning, the protesters stood in front of the oncoming headlights, blocking the road. The process server stepped forward and read the injunction. We listened quietly, then moved to the verge of the road, behind a spray-painted yellow line. Only those who had volunteered to be arrested moved forward and stood before the bridge.

Then the arresting ceremony began. One by one, each of the blockaders was asked to walk to a waiting bus. If they refused to move, they were carried. Some gave the "V for victory" sign. Once the last person had been arrested and deposited in the bus, the vehicle drove off, and the "criminals" were charged.

By the time the Clayoquot protest was over, more than eight hundred people had been charged, including several elderly women (the "Clayoquot grandmothers"), who were later led into court in leg shackles and handcuffs. The accused were tried in batches of thirty to fifty, unprecedented mass trials for North America and travesties of justice according to the defendants' lawyers. Almost all of those charged were found guilty, including Anne Wilkinson and her husband Merv, now in his

eighties. He'd been sustainably logging fifty-five hectares of old-growth forest on Vancouver Island for over fifty years — though people told him he was crazy. "I've been 'crazy' a lot in my life," Merv would answer, "and it's paid off."

At his trial, Merv gave a compelling speech about the unfairness of the logging practices the so-called justice system was protecting. His speech left many in tears. His sentence was community service — an irony, since Merv has been serving the community all his life.

Merv's sacrifice and the sacrifices of all who protested were not in vain. Forestry practices in Clayoquot Sound are better now, and the concept of "old-growth-free" forest products has gained acceptance around the world. Major telephone companies are now insisting that their phone books and telephone poles come from trees harvested according to ecologically sound, sustainable logging practices. And the Clayoquot story has sparked similar movements in other parts of Canada and in the United States, Europe and Japan.

Headlines and television pictures give a distorted view of protests, and sometimes this is done on purpose. I have watched a cameraman pan across several flamboyant protesters, only to

stop shooting as soon as a "respectable citizen" filled the frame. The demonstrators who appear on TV are also only the visible tip of a widespread, mostly volunteer, movement that includes thousands of nongovernmental organizations around the world. Some activists are local heroes and some — like American consumer advocate Ralph Nader and biotech-crop opponent Vandana Shiva — make advocacy their life's work. Others are genuine martyrs — like Chico Mendez, who was murdered by cattle ranchers for trying to stop the destruction of Brazilian rainforests, and Ken Saro-Wiwa, the Nigerian writer who was executed for his actions against human rights abuses and environmental destruction caused by oil developments. As unholy alliances between governments and corporations continue to be forged, our best hope for true democracy may lie with people like this and with the nongovernmental organizations that support them.

For every Clayoquot Sound, there are hundreds of volunteers — good people — who make personal sacrifices to protect and restore the natural environment. With their hearts and minds, their actions and their words, they offer hope for the future.

A View from the Mountain

I am standing on top of Mount Maxwell. As mountains go, it is quite modest, only 1,975 feet high, but its almost vertical cliffs give it a certain topographic distinction, and the conglomerate stones beneath my feet witnessed the twilight of the dinosaurs. Mount Maxwell was once part of continental uplands that began eroding about seventy-five million years ago, leaving deposits on massive submarine gravel beds. These beds rested on even older formations – the roots of 360-million-year-old mountains, which, according to the latest theory, originated in Australia and now act as the foundation of our own little mountain.

The story of the creation of this mountain evokes permanence, patience, adaptability and nobility – characteristics worth emulating. If we looked at time and geography from a mountain's perspective, we would have a more profound sense of history, we would be able to see far and wide, and benefit from the experience of people all over the globe. If we thought

in the way mountains were formed, we would treat the natural world with more respect.

As I walked to the top of Mount Maxwell, I passed through a grove of majestic Douglas firs, part of Salt Spring Island's original forest. In 1938, the Maxwells, an old pioneer family, set aside this wonderful piece of ancient nature for the enjoyment and benefit of the community. But nearby Maxwell Lake, an important source of drinking water for the island, met an unhappier fate. Part of the lake extends into a five-thousand-acre tract of land formerly owned by a German prince. When the prince died, his heirs sold the land to developers, who intend to log much of the mountain down to the lakeshore.

The developers have offered to sell the shoreline area to the community, but the price at last accounting was in the vicinity of half a million dollars. Will the island's residents be willing to pay that amount? The developers are not breaking any laws by making this offer or by logging the forest they now own. Are they to blame for not respecting the lake and its watershed and for ignoring the impact of logging on future generations? Or is society the culprit?

Thinking these thoughts of a lake and a mountain, I stand facing the view to the south. Salt Spring Island is spread out beneath me, a mosaic of farm fields (some dotted with sheep), a few barns and houses, and a little old white church. Rolling hills clad in dark forest frame the picture. Beyond the frame, at the end of the valley, stretches the long bay on which I live, its blue waters zigzagged with silver riffles that seem to reach all the way to the Pacific Ocean. Our house is a tiny brown wedge on the left, partway along the bay.

A bald eagle tilts its wings below me, then rides the air currents up the face of the mountain until it is a speck above me. With its fine-tuned vision, the eagle can see both me and my house in minute detail and considers both of us insignificant. It is watching for action in the water, a gleaming patch of herring driven suddenly to the surface by salmon below.

These days, the eagles have less occasion to plunge down to the bay to fish. There are fewer herring and many fewer salmon in the water. I wonder if the eagle's gaze strays out to the open sea, where the grey whales are migrating north to their summering grounds in Alaskan waters. My thoughts turn to a news item I heard on the radio this morning: This month, seven grey whales have been found dead in the waters of

Vancouver Island. Seven dead in one month! Preliminary testing has revealed the presence of PCBs and other toxins – another link between pollution and declining whale and fish populations. Recently, another whale was found dying on a nearby beach, apparently of starvation. Perhaps the chemicals in its body meant it could not absorb nutrients properly; perhaps the mammal could not find enough to eat in the overfished waters off the British Columbia coast.

Whales are not the only victims of damaged environments. I think back to my boyhood day in May, and my songbird-filled bower. The memory is all the more precious because migratory songbird numbers are plummeting as birds succumb to pesticides and deforestation in their tropical winter homes and their Canadian breeding grounds. Nature is resilient, but we are beginning to reach the limits of its endurance.

The eagle and I can see the snowy peaks of the Olympic Mountains of Washington State far to the south. Though it does not know it, as the symbol of the United States of America, the majestic bird represents a nation that has had great influence for more than half a century – sometimes for the worse, but often for the better. All the same, we need to

stop focusing on the notions of Progress and "bigger is better" that have powered North American society for so many years. By taking a longer view, we will discover healthier models of thought and behaviour in cultures around the world: models like the ecologically balanced communities of Holland, wildlife preservation in Israel, the sustainable practices of some tribal cultures – and thousands of others. Ideas like these are worth keeping; others must be thrown away. We must pick and choose.

At the beginning of a new millennium, we all stand at the top of a mountain that offers us spectacular views in all directions. We have more knowledge of nature than any other civilization in history. We can look beyond the sky and beneath the sea. We can see both the forest and the trees: We can count the rate of its destruction and tote up the cost of saving it. We can see all human activities – farming, fishing, manufacturing – their costs and their benefits. We can look back into distant history, to the origins of our behaviours and our beliefs, all the way to the birth of the human species itself.

We who live in the twenty-first century know more, own more and exert more power over our environment than any who have come before us. Our knowledge and our technology present us with a multitude of possibilities and choices. Why

do we hesitate to decide? Does the sheer multitude of options overwhelm us? This may be so, but if we wait too long, our shift toward a more responsible ideology could happen too late.

The eagle is soaring above the mountain higher and higher; if it were to fly beyond the blue, beyond the place where eagles can go, it would see a wonderful world – a place of infinite variety and complexity and remarkable resilience. It would see the planet that every astronaut has said was infinitely precious. What is so wonderful about this sphere? It is surely our natural and human heritage in all its complexity.

If we begin to think like a mountain, we will keep all that is truly valuable in this world and pass these treasures on to succeeding generations. All we need to do is pay attention and pay the price. I'd say the cost is more than worth it.

123

More Food for Thought

The following list of books explores some of the ideas and philosophies I've touched on in *Thinking Like a Mountain*. It represents only a small sampling of the growing body of literature written by people who are thinking hard about the problems of the planet and charting alternative ways to the future.

Adams, Patricia. *Odious Debts: Loose Lending, Corruption, and the Third World's Environmental Legacy*. London and Toronto: Earthscan, 1991.

Brower, David R. *For Earth's Sake: The Life and Times of David Brower*. Salt Lake City, UT: Peregrine Smith Books, 1990.

Brower, David R., with Steve Chapple. *Let the Mountains Talk, Let the Rivers Run: A Call to Those Who Would Save the Earth*. New York: HarperCollins West, 1995.

Copeland, Grant. *Acts of Balance: Profits, People and Place*. Gabriola Island, BC: New Society Publishers, 1999.

Goodall, Jane, with Phillip Berman. *Reason for Hope: A Spiritual Journey*. New York: Warner Books, 1999.

Hardin, Garrett. *Living within Limits: Ecology, Economics and Population*. New York: Oxford University Press, 1993.

Hartmann, Thom. *The Last Hours of Ancient Sunlight: Waking Up to Personal and Global Transformation*. Northfield, VT: Mythical Books, 1998.

Hawken, Paul, Amory Lovins and L. Hunter Lovins. *Natural Capitalism: Creating the Next Industrial Revolution*. Boston, New York, London: Little Brown, 1999.

Herman, Edward S., and Noam Chomsky. *Manufacturing Consent: The Political Economy of the Mass Media*. New York: Pantheon Books, 1988.

Jackson, Wes. *Becoming Native to This Place*. Lexington: The University Press of Kentucky, 1994.

Jacobs, Jane. *The Death and Life of Great American Cities*. New York: Random House, 1961.

Leopold, Aldo. *A Sand County Almanac and Sketches from Here and There*. Oxford: Oxford University Press, 1949 & 1968.

May, Elizabeth. *At the Cutting Edge: The Crisis in Canada's Forests*. Toronto: Key Porter, 1998.

Meyers, Norman, with Jennifer Kent. *Perverse Subsidies: Tax $s Undercutting Our Economies and Environments Alike*. Winnipeg: International Institute for Sustainable Development, 1998.

Moore, Michael. *Downsize This*. New York: Crown, 1997.

O'Hara, Bruce. *Working Harder Isn't Working: How We Can Save the Environment, the Economy and Our Sanity by Working Less and Enjoying Life More*. Vancouver: New Star Books, 1993.

Postman, Neil. *Technopoly: The Surrender of Culture to Technology*. New York: Vintage Books, 1993.

Qing, Dai. *Yangtze! Yangtze!* London: Earthscan; Toronto: Probe International, 1994.

Rifkin, Jeremy, and Robert L. Heilbroner. *The End of Work: The Decline of the Global Labor Force and the Dawn of the Post-Market Era*. New York: Putnam, 1995.

Safina, Carl. *Song for the Blue Ocean: Encounters along the World's Coasts and Beneath the Seas*. New York: Henry Holt, 1997.

Saul, John Ralston. *The Unconscious Civilization*. Concord, ON: Anansi, 1995.

Schumacher, E.F. *Small Is Beautiful: Economics as if People Mattered*. Vancouver, BC, and Point Roberts, WA: Hartley & Marks, 1999.

Suzuki, David, and Holly Dressel. *From Naked Ape to Super Species: A Personal Perspective on Humanity and the Global Ecocrisis*. Toronto: Stoddart, 1999.

Wilkinson, Todd. *Science under Siege: The Politicians' War on Nature and Truth*. Boulder, CO: Johnson Books, 1998.

Whenever I discuss the state of the planet, I am frequently asked, "Well, what can we do?" My answer is very simple. For a start, join a few organizations. There are literally thousands of such organizations and their hardworking staffs need your support. This is a small sample of the many publications we receive.

Audubon
National Audubon Society
700 Broadway
New York, NY
USA 10003
www.audubon.org

Canadian Wildlife
Canadian Wildlife Federation
350 Michael Cowpland Drive
Kanata, ON
Canada K2M 2W1
www.cwf-fcf.org

ELSA Canada
Box 45051
2482 Yonge Street
Toronto, ON
Canada M4P 3E3
www.elsacanada.com

finding solutions
David Suzuki Foundation
Suite 219, 2211 West 4th Avenue
Vancouver, BC
Canada V6K 4S2
www.davidsuzuki.org

The Gallon Environment Letter
506 Victoria Avenue
Montreal, PQ
Canada H3Y 2R5
Email: cibe@web.net

Nature Canada
The Canadian Nature Federation
Suite 606, 1 Nicholas Street
Ottawa, ON
Canada K1N 7B7
www.cnf.ca

Sierra
Sierra Club
HQ: 85 Second Street
San Francisco, CA
USA 94105-3411
www.sierraclub.org

Wildlife Conservation
Wildlife Conservation Society
2300 Southern Boulevard
Bronx, NY
USA 10460
www.wcs.org

World • Watch
Worldwatch Institute
1776 Massachusetts Avenue NW
Washington, DC
USA 20036-1904
www.worldwatch.org

Working for Wildlife
World Wildlife Fund Canada
Suite 410
245 Eglinton Avenue East,
Toronto, ON
Canada M4P 3J1
www.wwf.ca

World Wildlife Fund United States
1250 24th Street NW
Washington, DC
USA 20037-1175
www.worldwildlife.org

Acknowledgments

My wife Birgit's spirit and philosophy have travelled beside me for decades, as I evolved the ideas found in *Thinking Like a Mountain*. Through innumerable lectures and countless conversations with others, her patience and support have never flagged. Her environmental conscience has been a guiding light to me and our boys. More than anyone, she has encouraged me to peel back the layers of the onion of world problems in search of solutions that offer hope for the future.

This book itself was nurtured and given shape by Rick Archbold, who has worked with me on various publications for fifteen years or more. He has been a fine listener, compiler and craftsman, with a sure sense of balance, taste and judgment.

It was a joy working with Kathryn Dean during the final editing. I marvel at her care, commitment and incredible energy. My assistant of many years, Alexandra Fischer, has been a steadfast and creative help at every stage of this book's long journey, as she continues to be with the juggling act that is my life and career. With humour, generosity, skill and intelligence, she has kept this project moving steadily toward its goal. My other assistant, Kate Carson, has helped greatly with research and overcome more than a few technical challenges.

I would also like to thank the members of the team at Penguin Canada with whom I came into contact during this book's preparation. Cynthia Good, Publisher, and Jackie Kaiser, Executive Editor, believed in the project from the start and made many helpful suggestions along the way. Janice Brett, Director of Production, patiently oversaw our unconventional production schedule. And Linda Gustafson of Counterpunch created the perfect design to match my words and their spirit.

My "around-the-world" companion Bristol Foster has, as always, been an oracle, a good friend and an ear to the ground of environmental thinking.

My constant companion over half a century in the studio has been CBC Radio, especially its issues-related programs, and above all, the program *Ideas*.

Finally, I would like to thank the many academic groups, naturalists' organizations and business associations that have invited me to speak to them over the last four decades. These public forums, with their attentive audiences and searching questions, have been the incubators where I have been allowed to test and refine my thinking.

For further information on the topics discussed in this book,
visit Robert Bateman's website, at www.batemanideas.com.

CASCADE PAPERS ENVIRO ANTIQUE

ENVIRONMENTAL BENEFITS STATEMENT

Thinking Like a Mountain was printed on Enviro Antique, made with 100% post-consumer
waste, processed chlorine free. By using this environmentally friendly paper, Penguin Canada
saved the following resources:

wood	water	energy	solid waste	greenhouse gases
4,367 pounds	6,423 gallons	10,588 000 BTU	682 pounds	1,321 pounds

Source: www.ofee.gov